IMAGES of America

CHARLES COUNTY

The ~~family~~,

Hope you enjoy the

virtual tour.

All the best,

Jackie

2007

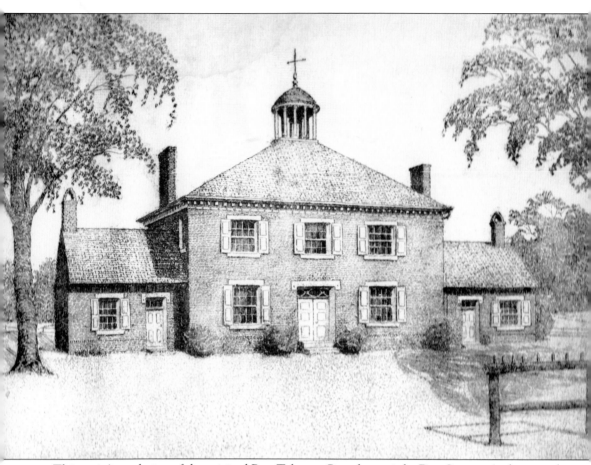

This artist's rendering of the original Port Tobacco Courthouse is by Don Swann. A photograph of the original courthouse built in the 1670s has not been found, so photographs of the third courthouse, built in 1819, were used as a template. Currently, a replica of the third courthouse has been restored to its original site and is open for tours. It contains many interesting pieces of Southern Maryland history. (Courtesy Society for the Restoration of Port Tobacco.)

ON THE COVER: In 1923, Frank Alexander Martin purchased the Wills Hotel and the adjacent land, where he built and operated the Central Garage. He proudly offered Standard Oil, which later became Esso, for 40 years. He is pictured to the far left with his son, Joseph Bret Martin, who took over the garage in 1958. In 1987, the name changed to Martin's Chevron and is now owned by his grandson, Marty Martin. It is one of the oldest continuously owned family businesses in Charles County. (Courtesy Martin Collection.)

IMAGES
of America

CHARLES COUNTY

Jacqueline Zilliox

ARCADIA
PUBLISHING

Published by Arcadia Publishing
Charleston SC, Chicago IL, Portsmouth NH, San Francisco CA

Printed in the United States of America

Library of Congress Catalog Card Number: 2007920239

For all general information contact Arcadia Publishing at:
Telephone 843-853-2070
Fax 843-853-0044
E-mail sales@arcadiapublishing.com
For customer service and orders:
Toll-Free 1-888-313-2665

Visit us on the Internet at www.arcadiapublishing.com

Thank you to all the history lovers who encouraged me to keep digging.

CONTENTS

ACKNOWLEDGMENTS

Until I started this book, I didn't know how much I didn't know. I began by looking into the archives of the Southern Maryland Studies Center at the College of Southern Maryland, but ended up in living rooms and sitting at kitchen tables listening to the stories of lifetime local residents. One resource for photographs and information would lead me to another and another. There is no telling the amount of historical treasure I could discover if I didn't have a deadline.

One of the best sources for photographs and oral histories was the college. The historically relevant information in the oral histories, done by John Wearmouth, was very helpful. From the past librarian, Sally Barley, to the current one, Patricia McGarry, I received valuable direction and resource support. They are truly the keepers of Southern Maryland knowledge. In the book, I have abbreviated the Southern Maryland Studies Center as SMSC.

It was surprising to discover who had what. Some people who seemingly had no important reason to gather and preserve information were nonetheless incredibly determined in their task, such as local historian Gene Robey, self-described unofficial mayor of Waldorf. Others who had deep roots in the community—Joyce Simpson of Waldorf, Bobbie Baldus of La Plata, and Buddy Linton of Nanjemoy—could rattle off facts from the beginning of the 20th century up to the present time with an accuracy of a history book.

Everyday people doing everyday things are whom I focused my attention on. In the early years, Charles County sustained itself by grit, determination, and a country sensibility that endures to this day. I saw that especially in the volunteers that formed the fire departments and rescue squads. I was impressed by the life of service many of them still lead, like Bill Cooke of Waldorf and Vic Bowling of La Plata.

Another organization that was incredibly helpful was the Society for the Restoration of Port Tobacco, with special thanks to Vivian Malchek and Sheila Smith.

I wish to thank all that allowed me into their homes and shared the information contained on these pages. I am also deeply appreciative of my good neighbor, Nancy Feuerle, for her editing skills.

INTRODUCTION

Charles County has some odd names for roads and places like Mattawoman, Pisgah, Chicamuxen, and Pomonkey—all leftovers from the days when the county was home to a few American Indian tribes such as the Potopaco, Piscataway, and Algonquin. The Native Americans in this area belonged to a larger territory called the Powhatan Confederacy by early traders. Hunting was good, the Native Americans were peaceful, and trade was established between Europeans and the tribes in the early 1600s.

By 1632, the colony of Maryland was started at St. Mary's City. Charles County's seat and first town, Port Tobacco, was chartered in 1658. The county primarily consisted of port towns. The interior had very few manors and farms, which were granted by the English crown at that time. Not until the American Revolution in 1776 did that change. Even then, growth came slowly to Charles County, by way of establishing agricultural roots. By the late 1800s, the Naval Proving Grounds at Indian Head were established, bringing much-needed jobs to the county. Towns sprang up around the newly built railroad in 1872, and when the county passed the 20th-century mark, agricultural trade was sustaining many service businesses.

It was around that period that photographs for this book were taken to relay the history of Charles County. This book focuses on the everyday happenings done by extraordinary, ordinary people who through their hard work and ingenuity made the county what it is today.

I would like to convey an interesting story that a photograph could not be found for that involved the La Plata Volunteer Fire Department. In the 1940s, La Plata VFD received a call from Calvert County to assist in fighting a fire at the Calvert Hotel in Prince Frederick. The crew raced down to Benedict, caught a 30-minute ferry ride over to Calvert County, and made it in time to watch the building collapse. It is hard to believe that was just 60 years ago. I will leave you to your pictorial journey, and hope that you enjoy it as much as I did.

One

TOWNS AND VILLAGES

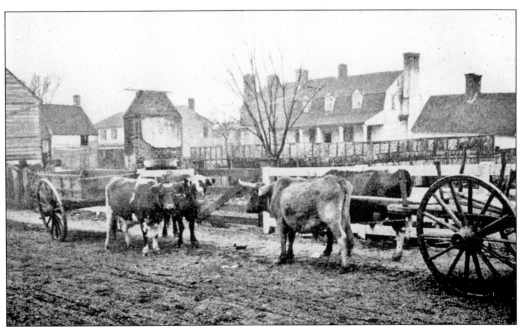

In its heyday, Port Tobacco was the second largest port in Maryland. It became an English naval port of entry for tax collection and trade. Initially called Charles Town, it was officially changed to Port Tobacco in 1820, named after the Potopaco Indians who first inhabited it. The two houses on the right, Chimney House (larger) and Stagg Hall, are all that remain. This photograph was taken about 1900. (Courtesy Society for the Restoration of Port Tobacco.)

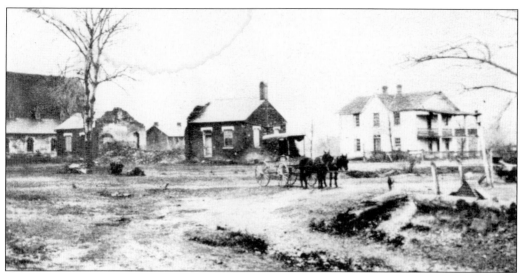

Port Tobacco was the seat for Charles County's government from 1658 to 1895. After the railroad came through La Plata in 1873, businessmen wanted to move the courthouse there, but it was voted down. The courthouse burnt down on August 3, 1892. Arson was suspected after the court records containing land deeds were discovered undamaged a few yards from the fire; arrests were never made. In the photograph, the remaining south and north wings of the courthouse are behind the mule wagon. Christ Church Episcopal is on the far left. In between the wings of the courthouse is the tiny jail. The white building with balconies is the Brawner-Smoot Hotel. (Courtesy Society for the Restoration of Port Tobacco.)

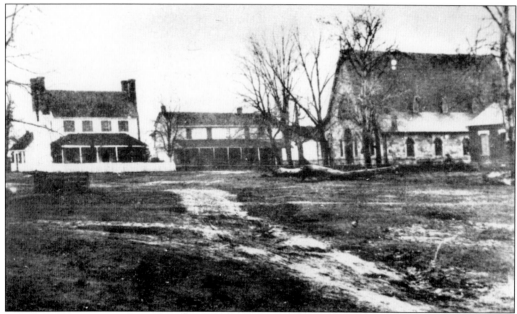

Pictured is the view of Port Tobacco about 1892, just after the courthouse fire. From left to right are the Wade House, the Centennial Hotel, and Christ Church Episcopal. In the back of the Wade House is the Wade General Store, which was located on Commerce Street. One of the other smaller roads was called Cheap Skate Road. The Wade family operated a store in Port Tobacco until the 1950s. (Courtesy Society for the Restoration of Port Tobacco.)

This is the third courthouse, built in Port Tobacco in 1819. There were two floors, the second used for jury deliberation and records. In the early years, court was held in private homes until the first courthouse was completed around 1675. The second courthouse was finished in 1727 and was destroyed by a tornado. Judges traveled on a circuit and trials were held in certain months, so even an innocent man would have to stay in jail for months before his trial. Many times three judges and a jury were present for cases. On some accounts, the convicted were tried and hung on the same day. It is presumed that the men in this photograph were judges and court officials. (Courtesy Society for the Restoration of Port Tobacco.)

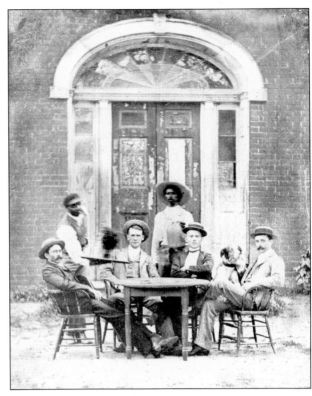

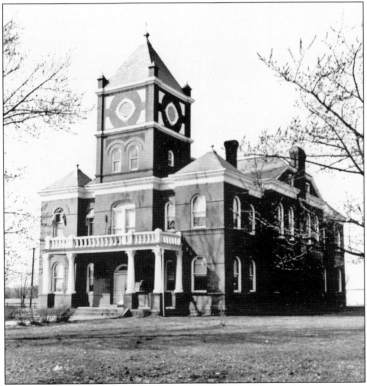

The first courthouse in La Plata was architecturally styled in Victorian Renaissance Revival in 1895. On the bottom floor were the county offices, and the second floor had a courtroom that seated 250. There were also private rooms for jurors and members of the bar. By 1974, additions were made to the north and south sides and the building's facade was changed to a Georgian style, which included a cupola. (Courtesy Kittie Newcomb Collection.)

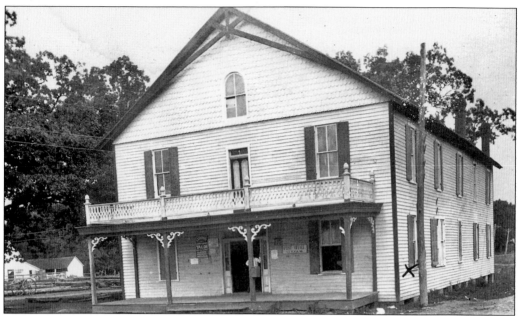

La Plata Town Hall was built in the 1890s on Charles Street. In 1914, the post office, tailor, cobbler, barbershop, and doctor's office occupied the back of the first floor. The second floor served as a center for social functions such as church suppers, town meetings, political rallies, and a movie theater. After being destroyed by a fire in the 1940s, a movie theater was built in its place, which is now the home of the Port Tobacco Players Theater. (Courtesy Sharon Bolton.)

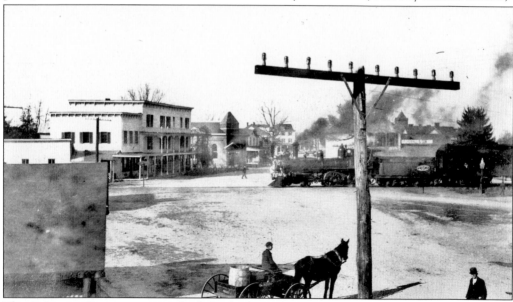

The Baltimore-Potomac train, which birthed La Plata, was initially intended to service the population of Pope's Creek and the surrounding towns such as Port Tobacco. Train service began in 1873. When this photograph was taken in 1925, La Plata was the county seat and one of largest towns in Charles County. The passenger train business stopped in 1949. The three-story building on the left is the La Plata Hotel. On the far right, directly behind the second car, is T. R. Farrall's general store. (Courtesy Sharon Bolton.)

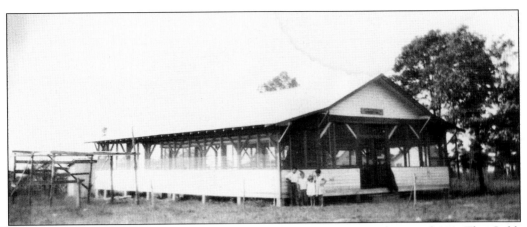

In 1926, there were 87 homes on Cobb Island, with a summer population of 600. The Cobb Island Citizens Association formed in 1927, and in the summer of 1928, at a cost of $11,000, the community hall was built. The smallest child standing in front of the hall in the photograph is Dottie Kitchen. (Courtesy Dorothy Kitchen Jenkins.)

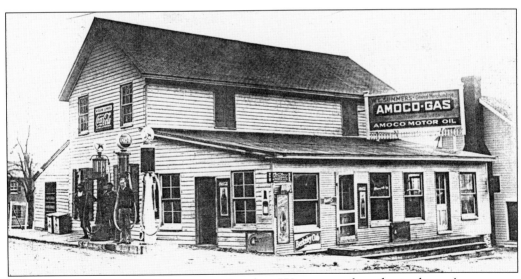

The town of Bryantown got its name after the 1778 census, when the innkeeper's name was used. By 1890, Bryantown was the second most important community in Charles County, but after the railroad bypassed it in 1872, it became a quiet residential area. W. E. Summers General Merchandise is pictured in the 1930s. (Courtesy SMSC at the College of Southern Maryland.)

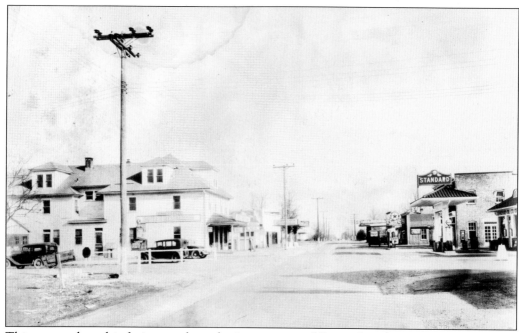

This unpaved road is facing north at the intersection of Route 5 and Route 925 in the early 1900s. The large structure on the left is the Stonestreet Hotel and Restaurant, later to become Carlton Hotel in the 1930s. On the right, where the Standard Oil sign and gas pumps are, is the Neubert Restaurant. (Courtesy SMSC at the College of Southern Maryland.)

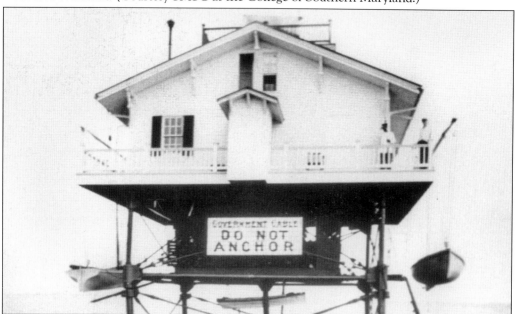

The Cobb Point Bar Lighthouse was built a mile off the southern tip of Cobb Island, on a sandbar where the Potomac and Wicomico River meet. It began operations in 1889, outfitted with kerosene lamps. The foghorn was sounded by machinery every 15 seconds. It was destroyed by fire in 1939. An automated bell and light were placed on the platform in 1940. (Courtesy SMSC at the College of Southern Maryland.)

This photograph is of Charles Street facing westward in the 1940s with an unusual traffic jam. The courthouse, built in 1895, is the tall building with the tower on the left. To the right of it are the Southern Maryland National Bank, Stumble Inn, Mitchell Hardware, Lyon and Nalley store, and the first Washington Coca-Cola Bottling Works plant. (Courtesy Betty Levering.)

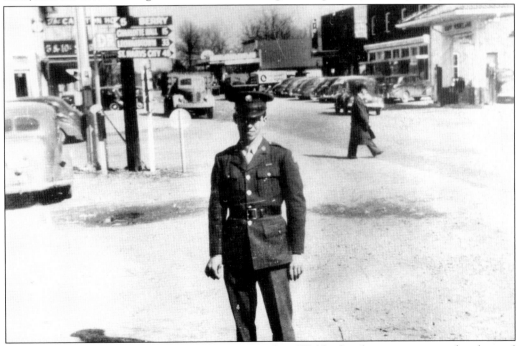

During World War II, servicemen were stationed in Waldorf to keep an eye on the sky and radioed into Washington, D.C., if they saw enemy aircraft. This young soldier was one of four that occupied a one-story building on the grounds of the Waldorf School. He is at the intersection of Route 5 and Route 925. (Courtesy SMSC at the College of Southern Maryland.)

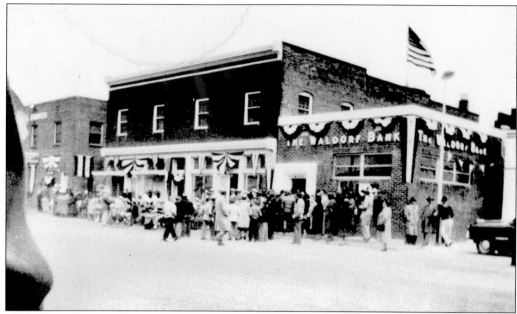

The Waldorf Bank was located on the corner of Route 5 and Route 925. It opened on April 15, 1950, and has the distinction of being the first bank in Waldorf. To the left is a two-story apartment building, and to the left of that is Louis Groves's Bar, currently the Gold Mine Saloon. (Courtesy SMSC at the College of Southern Maryland.)

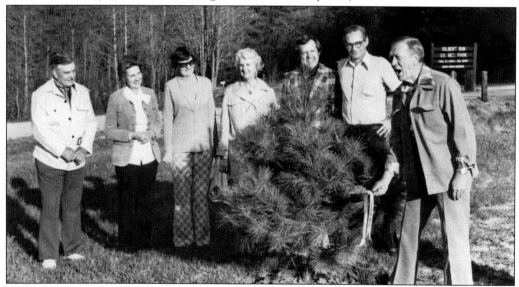

Gilbert Run Park began as the Gilbert Run flood project to prevent excess from a creek beginning in Prince George County from overflowing into Charles County. The dam at Gilbert Run was named Wheatley. After the dam was built and the lake was created, additional land was purchased around it to create the park. Attending the dedication ceremony in 1965 to begin beautification with an evergreen tree were, from left to right, Bobby Gray, County Commissioner Eleanor Carrico, unidentified, Kathryn C. "Kittie" Newcomb, County Commissioner Jim Dent, George Dyson, and President of the County Commissioners Ray Tilghman. (Courtesy Kittie Newcomb Collection.)

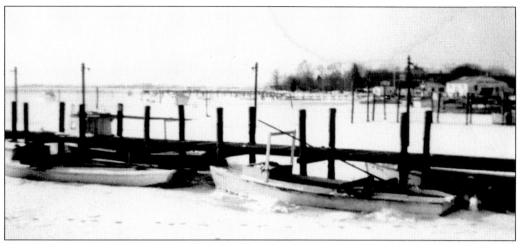

Benedict was originally known as Benedict-Leonardtown in 1695. It was named after Benedict Leonard Calvert, the fourth Lord Baltimore and Lord Proprietor of Maryland. Benedict is the only Charles County community on the Patuxent River. In late 1600s, a village started to grow from the tiny cottages that sprang up to accommodate the shipbuilders working to produce all types of small boating vessels. By 1900, it was well known as a port town for the tobacco and lumber industry. During the steamboat days, the Weems Line serviced Benedict. The photograph shows boats locked in ice at the Benedict pier in 1966. The Benedict Bridge, in the background, was built in 1954. The photograph is reversed. (Courtesy SMSC at the College of Southern Maryland.)

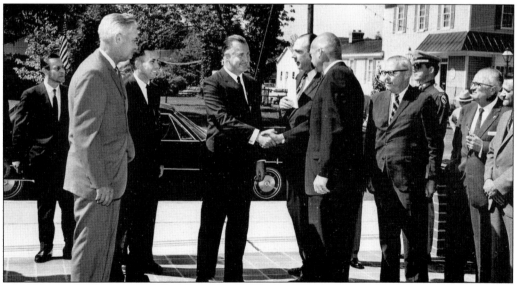

From 1967 to 1969, Spiro Agnew was the 55th governor of Maryland. He paid a visit to Charles County during his term to discuss road improvements in the county. Officials from the town of La Plata greeted him on the steps of the courthouse. He is seen here shaking the hand of John C. Hancock, Maryland state attorney. Between him and the governor is Reed McDonough. The second man from the left is Pat Mudd, clerk of the court, with John Thomas Parran between him and Agnew. To the right of John C. Hancock is J. Dudley Digges, attorney, whose office building was directly behind him. J. D. Digges shared his office building with Maryland Bank and Trust. (Courtesy Kittie Newcomb Collection.)

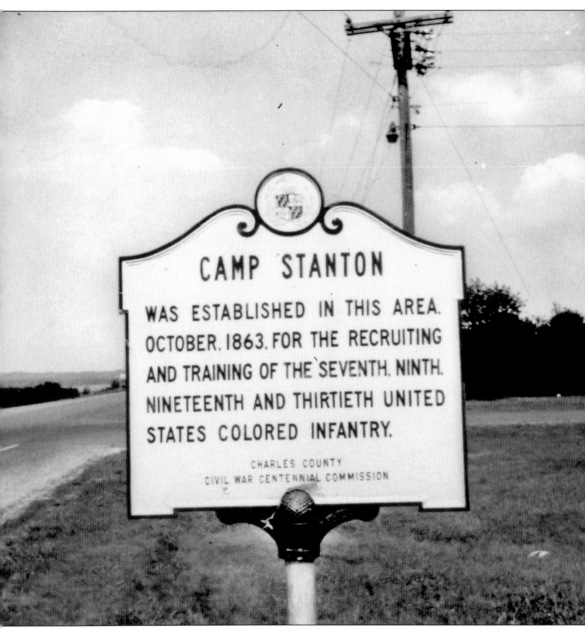

CAMP STANTON

WAS ESTABLISHED IN THIS AREA.
OCTOBER, 1863, FOR THE RECRUITING
AND TRAINING OF THE SEVENTH, NINTH,
NINETEENTH AND THIRTIETH UNITED
STATES COLORED INFANTRY.

CHARLES COUNTY
CIVIL WAR CENTENNIAL COMMISSION

This road marker is to memorialize the area in Benedict that was known as Camp Stanton during the Civil War. Army life was an appealing alternative to black men who couldn't find work. However, the winter of 1863 was devastating to their ranks, and many died. When the war ended, the camp closed, and the bodies were moved to the new Arlington National Cemetery. (Courtesy SMSC at the College of Southern Maryland.)

Two

INDUSTRY

After tobacco is harvested and dried, it is placed into a large, wooden barrel called a "hogshead." This merry band posing beside their shipment at Brentland Wharf on Port Tobacco Creek are the Barnes and Brawner family. In 1881, it cost approximately $2 per hogshead to ship to the tobacco warehouses in either Baltimore or Alexandria. Freight reached their destinations on the same day it was shipped. (Courtesy Sherrie Sanders.)

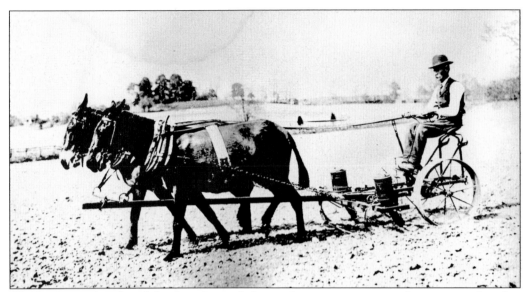

Charles County's rich and fertile soil provided enough resources to not only sustain settlers, but also to make a profit for them. Tobacco became the cash crop for international trade, but corn, soybeans, and hay were also important. This photograph was taken on the George W. Berry farm near La Plata in the spring of 1907. It shows a corn planter with two cans on each side for seed. (Courtesy Society for the Restoration of Port Tobacco.)

Tobacco was hauled from the field by wagon after harvesting to the barns for drying. Young tobacco is growing in the foreground of this photograph. The man driving the team is John Butler on the Howard Farm in Waldorf seen around 1910. (Courtesy SMSC at the College of Southern Maryland.)

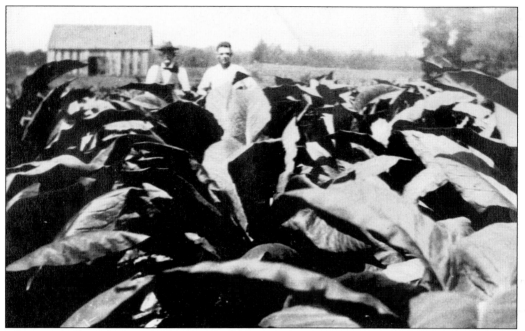

John Mitchell Cochrane, pictured in the hat, owned a general store in La Plata and a tobacco farm near White Plains. He and Hampton Robey are standing behind Maryland Type-32 tobacco that is ready to harvest. Behind them is the tobacco barn with its vertical barn doors open to allow the tobacco already hanging in it to dry. (Courtesy Kittie Newcomb Collection.)

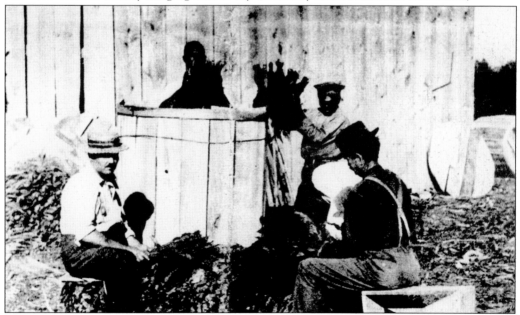

For centuries, dried tobacco was compacted into a hogshead weighing 600–800 pounds for shipping to market. It was made like a wooden barrel and banded with metal rings. From left to right are (first row, sitting) Hannon Robey and Walter Berry; (second row) Pat Brown and Milbert Chapman sorting tobacco on the Howard Farm in Waldorf. (Courtesy SMSC at the College of Southern Maryland.)

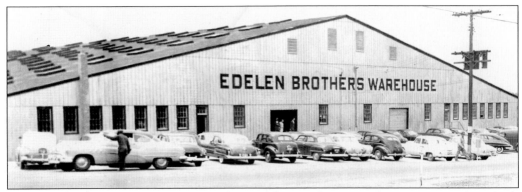

In 1939, Robert Jameson, Willson Bowling, Robert Downing, and Augustus Cooksey built Edelen Brothers Warehouse on the south end of Maple Street. It was one of three bonded tobacco warehouses in Southern Maryland. Because of its size, it was also used for social and public events. It burned down in 1974. (Courtesy Society for the Restoration of Port Tobacco.)

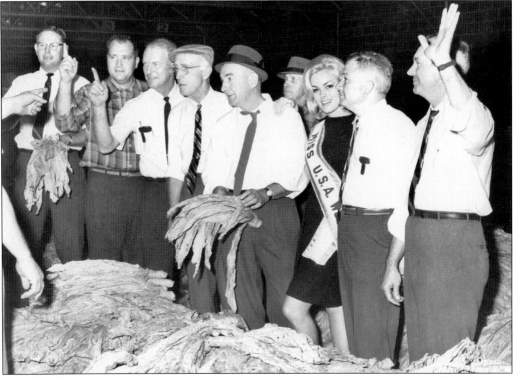

Ira Dell "Snooks" Newcomb Junior, pictured holding tobacco leaves to the left of Miss U.S.A., was the head buyer for the American Tobacco Company for 35 years. He traveled six months out of the year to the various tobacco auction houses that sold different types of tobacco. Maryland tobacco was called the loose-leaf market and was air cured. The Old Belt sold crops cured in southern Virginia and northern North Carolina and was where tobacco was first auctioned. Southwestern Virginia through eastern Kentucky and Tennessee were known as the Burley Belt. Their tobacco was dark and bitter and the least favored. Eastern South Carolina and southern North Carolina were known as the Bright Belt; they produced a yellow tobacco from being flue-cured, or dried by heat. Tobacco was sold by the pound and in grades ranging from one to four. (Courtesy Kittie Newcomb Collection.)

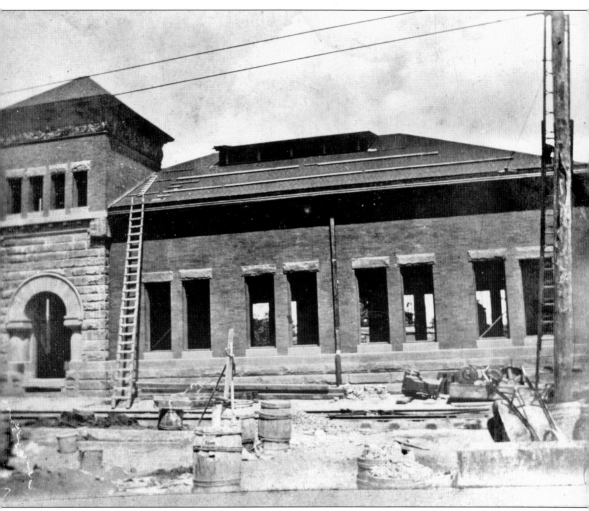

In 1890, the Bureau of Ordinance began construction of the new Naval Proving Ground on what was called the Indian Headlands (the original name for Indian Head). The proving ground was created to test guns, armor, shells, and mounts, then moved into standardization of shells and powder. During World War I, the name was changed to the Naval Powder Factory because they produced massive amounts of smokeless powder for the Navy. The R & D building pictured here was built in 1945. (Courtesy SMSC at the College of Southern Maryland.)

Pictured is Herman James Simms, a second-generation waterman. His career began when he moved to Rock Point in 1957 to work on his father's boat. He eventually moved to Cobb Island and purchased his own boat. To support his wife, Mary Ellen, and eight children, he harvested oysters, crabs, or fish. The Cobb Island Bridge can be seen in the background. (Courtesy Simms Collection.)

The La Plata Mill and Supply Company on Kent Avenue is one of the earlier businesses started in La Plata. The business records go back to 1892, when J. Benjamin Mattingly owned the gristmill known as the La Plata Milling Company. The mill is now owned by the Winkler family and sells lumber, building, and farm supplies. In the photograph, the dirt track behind the middle building was where the Winkler children learned to drive. (Courtesy Frances Winkler.)

Charles County was once known as one of the richest oyster grounds in the nation. There were canneries at Rock Point, Issue, Cobb Island, and Benedict to handle the millions of bushels caught yearly. In 2003, only 200 bushels of oysters were harvested from the Potomac and its tributaries. Runoff from farms and residential areas have been part of the cause. Water runoff to the rivers brings with it dirt, chemicals, sediment, and bacteria that affect the salinity of the rivers, stresses fisheries, and cause diseases. Today there is a study on the introduction of a disease-resistant Asian oyster. The photograph is of the Potomac Fish and Oyster Company on Rock Point. Commercial fisherman and farmer Edgar Coulby, and Baltimore seafood dealer William J. Nollmeyer opened it in 1945. In 1946, they were producing 2,500 gallons of shucked oysters a week. It closed in 1952. (Courtesy Dorothy Kitchen Jenkins.)

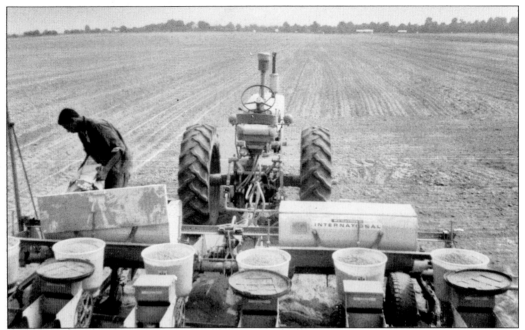

Located at the toehold of Charles County on the Patuxent River is a large ranch/farm known as Serenity Farm. Capt. John Smith explored the Patuxent River in 1608 and noted Native American villages were in the area. In the Colonial period, Serenity was part of Calverton Manor that was owned by the many Lords Baltimore. After the American Revolution, the manor was sold in parcels as confiscated British property. The current owners, the Robinson family, purchased it in 1965. (Courtesy the Robinson-Via Family Papers, 1845–2001, Archives Center, National Museum of American History, box number 17.)

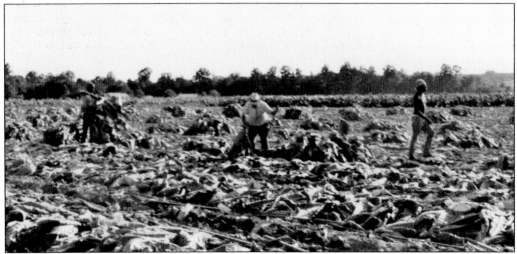

Serenity Farms, on the Patuxent River, used to grow the most lucrative crop in Southern Maryland, tobacco. They took the 10-year buy-out offered by the State of Maryland in 2000. Now they only grow one acre for educational purposes. The photograph shows Henry Goldsmith, center, and two unidentified workers spearing tobacco, readying it to hang for drying. (Courtesy the Robinson-Via Family Papers, 1845–2001, Archives Center, National Museum of American History, box number 17.)

Pictured are the Amish bringing their tobacco crop to market by horse and wagon. Once a week, the Hughesville Tobacco Warehouse would have an Amish day, which allowed their horses and wagons to have more room to maneuver. Some would hire a truck to bring them, but most traveled the old-fashioned way. (Courtesy Jane Schultz.)

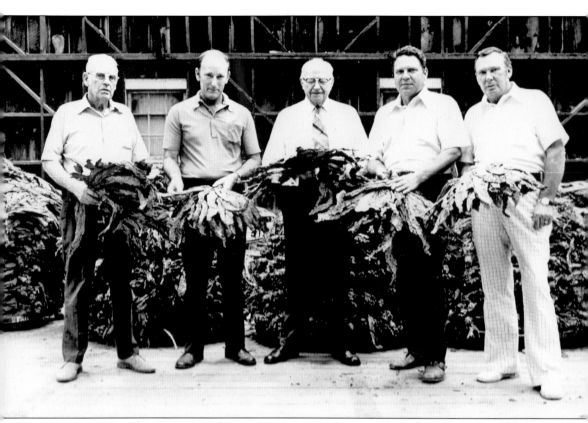

By the 1960s, the Farmer's Tobacco Auction Warehouses in Hughesville and Waldorf were incorporated. Pictured holding tobacco leaves from left to right are unidentified, warehouseman Jim Bowling, unidentified congressman from North Carolina, warehouseman and owner Jimmie Schultz, and auctioneer "Spec" Edwards. The Farmer's Tobacco Auctions stopped in the spring of 2006. (Courtesy Jane Schultz.)

Three

COMMERCE

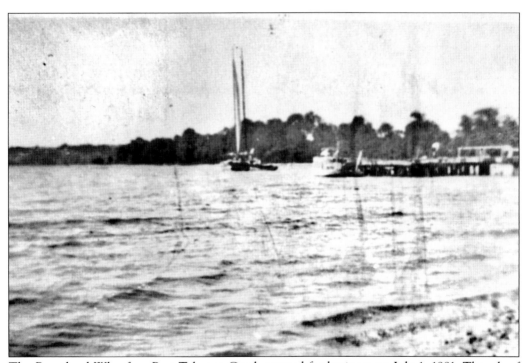

The Brentland Wharf on Port Tobacco Creek opened for business on July 1, 1881. The wharf was 280 feet long and accommodated steamers from Baltimore, Washington, and Alexandria. There was a warehouse, post office, and store on it. William M. Brent was postmaster until June 1887, followed by Josie Brent until December 1925, which is when it closed. (Courtesy Sherrie Sanders.)

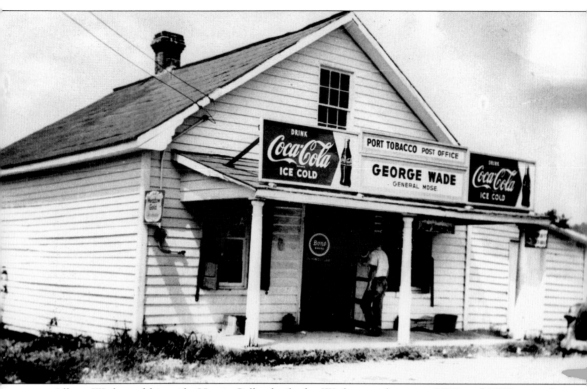

Albert Wade and his wife, Hattie Selby, built the Wade store between 1880 and 1900 near the one-room schoolhouse in Port Tobacco. It was a general merchandise store that also housed the post office. The store closed in 1952. (Courtesy SMSC at the College of Southern Maryland.)

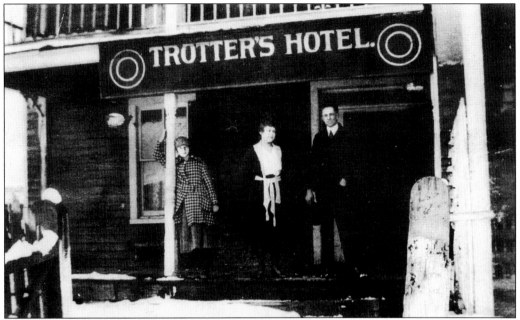

Trotters Hotel was located near the railroad tracks on Route 5 in Waldorf and was owned by Peter and Rosella Trotter. It was a large, two-story, frame house with a blacksmith shop and a bar. Rosella and her daughters did all the cooking, and meals were served to those traveling by horse or train. On the porch from left to right are Thelma Trotter, Irene Trotter, and unidentified. (Courtesy Joyce Simpson.)

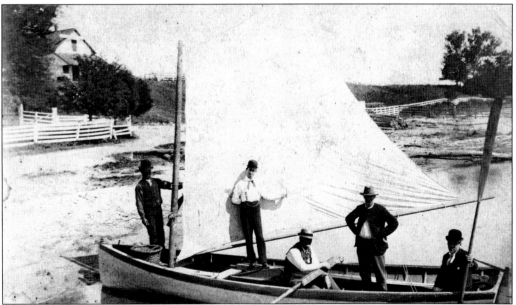

In 1898, Riverside, on the Potomac River in Nanjemoy, featured a 400-foot-long pier built by Robert Marbury to accommodate commercial boats that sailed to/from Baltimore, Maryland, and Norfolk, Virginia. At the top of the hill was Nanjemoy Store, at left in the photograph, also owned by Robert Marbury. It had been in continuous operation for 250 years when it closed in the 1950s. (Courtesy Society for the Restoration of Port Tobacco.)

Thomas Richard Farrall arrived in La Plata to open the first general merchandise store next to the newly laid Popes Creek Railroad in 1873. In 1889, Farrall moved into a bigger facility on the opposite side of the railroad tracks and operated it until his death in 1926. Reginald A. Farrall continued in his father's steps until his death in 1941. The Farralls' first store, pictured about 1960, originally had an open porch on the front. (Courtesy Barbara Farrall Baldus.)

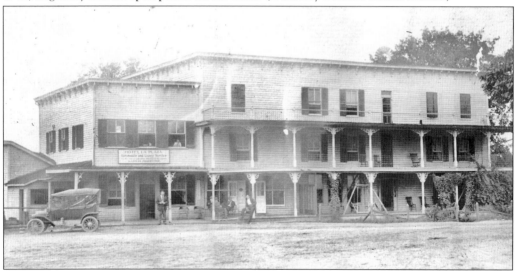

The La Plata Hotel, formerly Smoot Hotel, was bought by Charles E. Posey in 1904 then sold to his brother, Conrad Posey, in 1906. The hotel boasted a bar, poolroom, barber shop, dining room, and livery stable. Some of the hotel's best customers were traveling salesmen. David Smoot constructed the hotel in 1892. It was located where Casey Jones restaurant is now. (Courtesy Sharon Bolton.)

Mattingly's General Store was already in operation in the town before Indian Head was incorporated in 1920. Built about 1894 on what became Mattingly Road and Strauss Avenue, the store housed the town's first post office, which opened in 1898. Sarah Mattingly, Francis's wife, was the first postmistress. New arrivals to Indian Head would go to Francis if they were looking for a job or place to live. He was the first president of the town commissioners. Pictured is the store on the left with three men on the porch. The men are unidentified but may be a few of the four Mattingly boys who worked in the store, Joseph, Lewis, James, and Charles. The Mattinglys also opened a hotel in 1909. It is to the right of the store. (Courtesy SMSC at the College of Southern Maryland.)

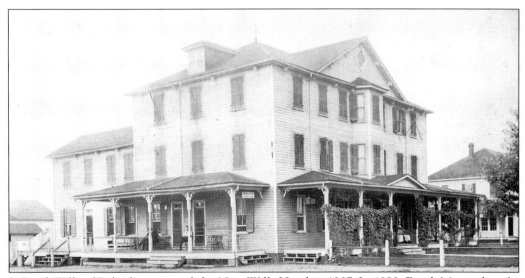

P. Reed Wills of Bel Alton opened the New Wills Hotel in 1907. In 1923, Frank Martin bought it and the property on which he opened Central Garage. In 1929, Martin sold to W. Pinckney Hawkins, who turned the rooms into apartments and offices. The first telephone operators in La Plata, Lillian Posey and Ray Bailey, had their switchboard in this building. It is now the Carrico building. (Courtesy Sharon Bolton.)

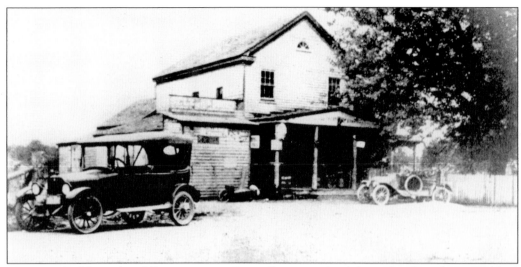

This was the Howard and Berry store on Route 5, just south of the railroad tracks in Waldorf. The first post office for Waldorf was there. The small attached building on the left was the Selz shoe store. The Howard and Berry store closed in 1932, and in the early 1940s, it became the First Baptist Church of Waldorf. After that is was the Friendly Tavern. (Courtesy SMSC at the College of Southern Maryland.)

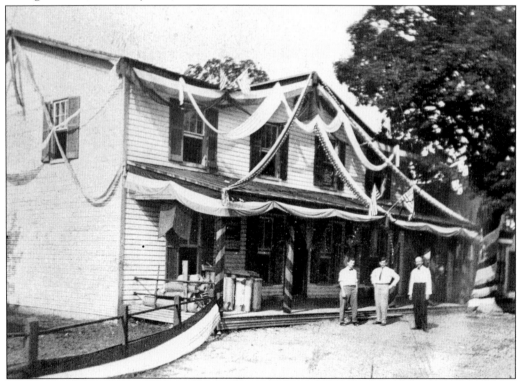

John Mitchell Cochrane Company, in La Plata, was a general merchandise store that carried everything—molasses to gunpowder and pharmaceuticals to clothing—when they opened in 1912. John retired in 1933, and his two sons-in-law, John P. Hancock and Otis A. Barnes, took it over and ran it until May 1946. (Courtesy SMSC at the College of Southern Maryland.)

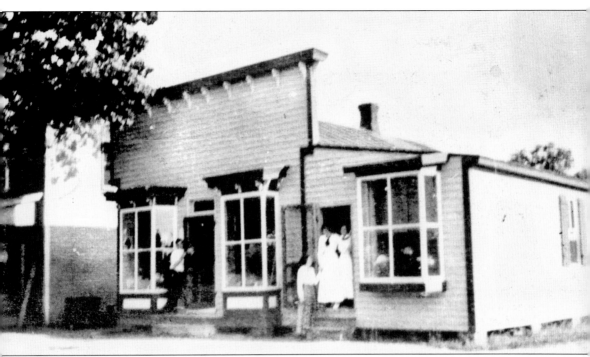

This is the first of three P. S. Bowling and Company stores on the corner of Charles Street and La Grange Avenue. The milliner sat in one of the bay windows while making hats. The store opened in 1913, and this photograph was taken in 1914. Shortly thereafter, it was destroyed in a fire then rebuilt in 1919. The third store was built in 1953 and closed in the 1980s. (Courtesy Kittie Newcomb Collection.)

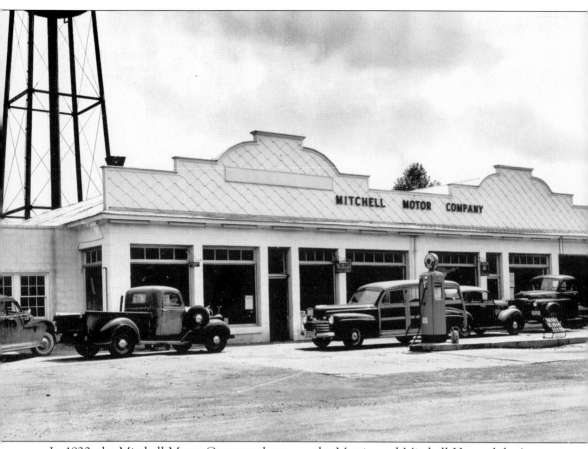

In 1920, the Mitchell Motor Company began as the Martin and Mitchell Hupmobile Agency. After Frank Martin, Hugh Mitchell's partner, left in 1922, Mitchell changed the name to Mitchell Motor Company and eventually switched over to the Chrysler brand. He continued in business until 1971. The building is located across from the courthouse on Charles Street, where Bernie's Frame Shop now is. (Courtesy H. Maxwell Mitchell Jr.)

In 1919, the Volstead Act of Congress placed a ban on the making and selling of alcoholic beverages. Many locals were active in and profited from this illegal business. The federal agent in the photograph was local Waldorf resident Charles Brewer. (Courtesy SMSC at the College of Southern Maryland.)

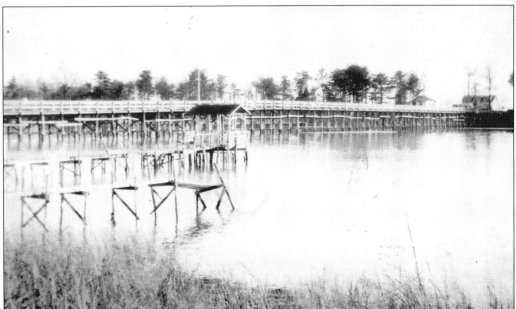

The 1923 single-lane wooden bridge that went over to Cobb Island was farther north than the current bridge site. Mr. Bannister built a large house on the southeast corner of Bridge Road and Cobb Island Road for a general store and meeting place. The house on the far right in the photograph is the Bannister Store. (Courtesy Dorothy Kitchen Jenkins.)

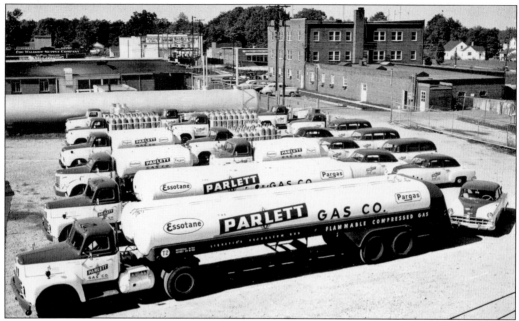

Lawrence and Louise Parlett came to Southern Maryland to start a plumbing and heating business in 1925, which grew to include a propane gas branch. In 1936, they decided to focus just on the propane business. By the 1950s, the business had expanded throughout Maryland and Virginia. This photograph shows the fleet at the main headquarters in Waldorf about 1950. (Courtesy William F. Cooke.)

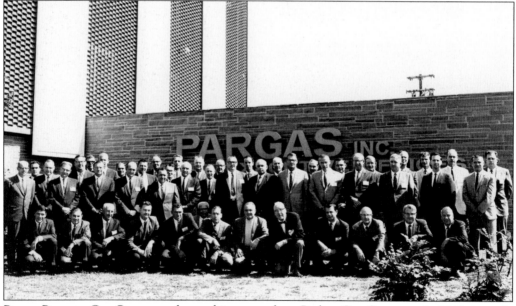

Pargas Propane Gas Company changed its name from Parlett Gas Company in 1960 to ready itself for public sale on the New York Stock Exchange. Pargas common stock was listed on the exchange in 1966. In 1967, Pargas merged with Pacific Delta Gas, adding 80 new locations. The Suburban Propane Gas Corporation acquired Pargas in 1985. Pictured is the managing staff during the 1960s. (Courtesy Joyce Simpson.)

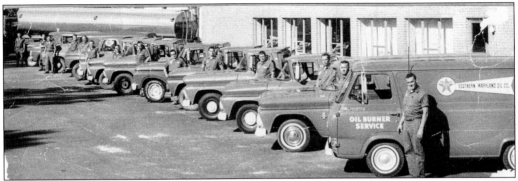

In 1926, two engineers, Jim Wills and Harold Swann, acquired the La Plata Oil and Mechanicsville Oil Companies, later known as Southern Maryland Oil. The company sold gasoline and heating and motor oil. There were eight employees, and product was received by rail. In 1936, the company bought 2,000-gallon trucks to bring oil from Baltimore to the Owings Plant. Pictured is the fleet of 1964. (Courtesy Southern Maryland Oil Company.)

Louis Groves, the man on the left, owned Groves Bar and Restaurant on Old Washington Avenue. He was also a barber and built a little barbershop on the side of the building. Hair cuts cost 25¢ in the 1930s. The man next to him is unidentified. Groves Bar is now the Gold Mine Saloon. (Courtesy SMSC at the College of Southern Maryland.)

Kerrs General Merchandise store was operated by I. M. Kerr, the lady on the left. Kerr started her store by making hats, then she carried groceries, eventually becoming a general merchandise store. The store was on Route 5, just before the railroad tracks. (Courtesy SMSC at the College of Southern Maryland.)

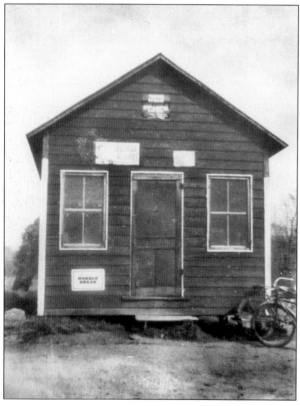

In the 1930s, African American husband and wife Smith and Bertha Gaines opened a country store on Tayloe's Neck Road and Route 6. Their 30-acre property bordered Nanjemoy Creek. The area was the most enterprising farming region in Southern Maryland. The Gaines store closed in the early 1950s. (Courtesy SMSC at the College of Southern Maryland.)

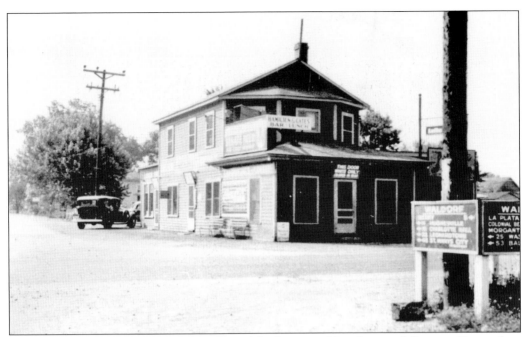

Hamilton and Gates Restaurant was started by Jennings Hamilton and Benson Gates when Benson returned from World War I. It was on the corner of Route 5 and Old Washington Avenue. It was a popular spot for folks traveling from Washington, D.C., on their way to St. Mary's County to have a bite of lunch or dinner. Benson raised his own vegetables for the restaurant. In later years, they added the front porch and enclosed it. Then on the back side, they built an area with a bar and pool tables. The restaurant was a local favorite that hosted many a late-night card party. The small sign over the door reads "This door whites only—Colored in rear." The street sign on the right gives the miles to the surrounding towns. Hamilton and Gates Restaurant was located where Korner Liquors now is. (Courtesy SMSC at the College of Southern Maryland.)

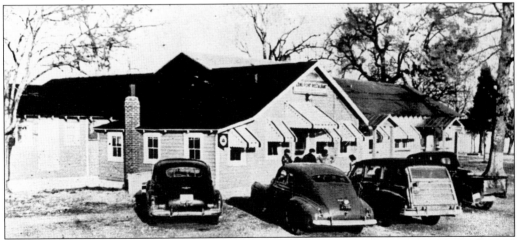

Shymansky's Restaurant, known as the Long Point Restaurant in the late 1940s, was located where the second and current Cobb Island Bridge is. The Long Point Restaurant was built by Mortimer Hill and later became managed by John "Smitty" Smith. Smith later opened Captain John's Restaurant a few yards away. (Courtesy Dorothy Kitchen Jenkins.)

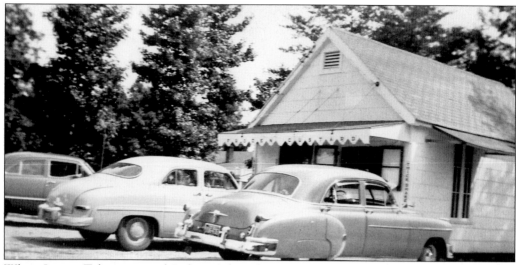

When Louise Tolson married Robert Schroeder in 1949, Louise's father asked them if they wanted to invest in his new ice-cream shop on Old Washington Road in Waldorf. They were the first fast-food restaurant in Waldorf when they added a few food items like all-beef hamburgers and French fries to the menu. They also had a few slot machines in the shop. (Courtesy Louise Schroeder.)

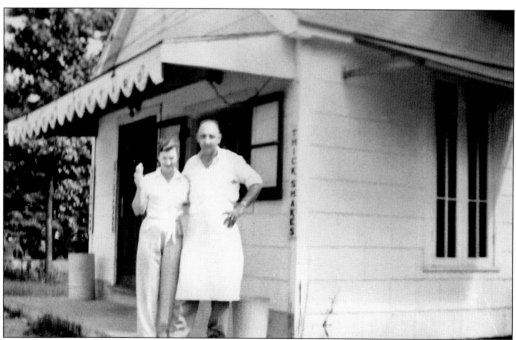

Eventually Robert and Louise bought it and renamed it Bob-Lu Dairy Mart. Bob was for Robert and Lu for Louise. Bob attended Maryland University for a class on ice-cream making. There he learned to add mallow mix for fluffier ice cream and added flavors to create delicious milk shakes that cost 30¢. Louise and Bob are pictured on the front porch of their ice-cream shop. (Courtesy Louise Schroeder.)

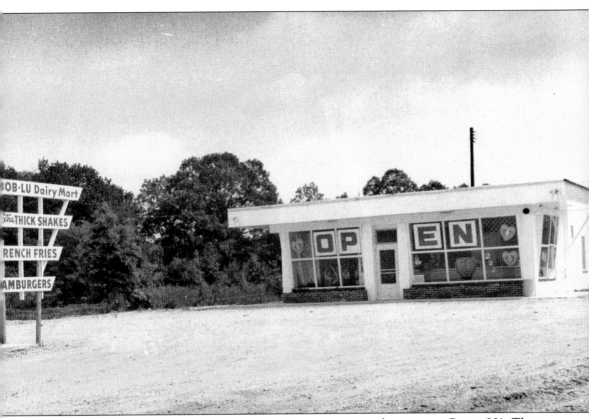

In 1955, Bob-Lu Dairy Mart moved across the street to a great location on Route 301. Their menu expanded, eventually the slot machines were replaced by pinball machines, and their son, Robbie, took it over when his dad passed in 1990. It is now the home of Danny's Hamburgers. (Courtesy Louise Schroeder.)

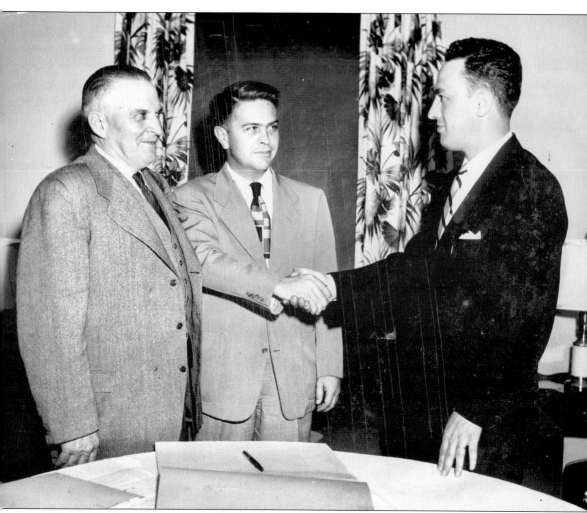

Samuel C. Linton Sr., on the left, was general manager of the Maryland Tobacco Growers Association until his retirement in the 1970s. All Maryland tobacco was collected in Baltimore from local growers and sold collectively for the highest price on the international market. The best tobacco in the world was slow burning with the lowest tar and nicotine, which was grown in five counties in Southern Maryland. (Courtesy Samuel C. Linton Jr.)

Four

LOCAL PERSONALITIES

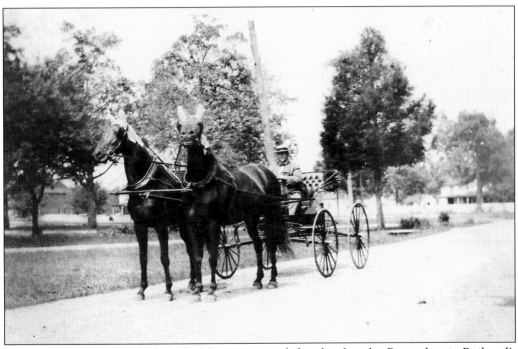

The first doctor in Waldorf, G. O. Monroe, arrived shortly after the Pennsylvania Railroad's Bowie–Popes Creek Line started in the early 1870s. Waldorf was originally called Bean Station after the largest family in the area at the time. They were related to the Dr. Bean arrested for treason against the crown during the War of 1812, whom Francis Scott Key successfully paroled. Key was onboard an English ship in Baltimore Harbor defending Dr. Bean during the bombing of Fort McHenry, and there he wrote the poem that became the national anthem, "The Star Spangled Banner." Dr. Monroe had a brother who practiced law in Baltimore. During a legislative address, he requested the name of Beantown be changed to Waldorf. He explained the word Waldorf was a German word meaning "village in the forest," which described the area. Dr. Monroe is pictured driving his horse and buggy on Route 5 near his home. (Courtesy Beth Moreland.)

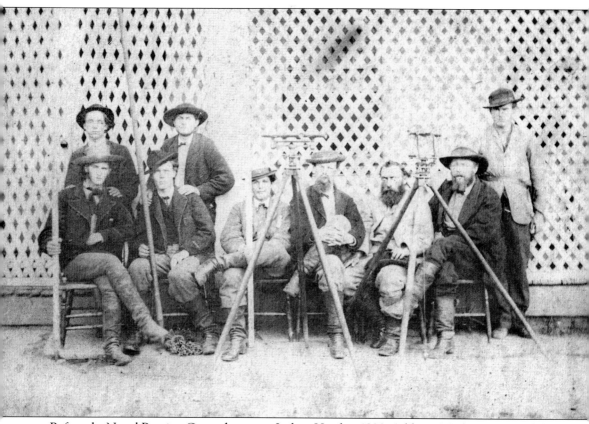

Before the Naval Proving Ground came to Indian Head in 1890, Addison Marbury surveyed that neck of land for the town of Indian Head. When the navy took over the section of land they still occupy, part of the town that Marbury surveyed, including Strauss Avenue and Mattingly Avenue, remained as he planned it. Addison Marbury was raised in Riverside, near Nanjemoy, but built a house just to the north. When the area received its own post office, a name was sought from the residents by a poll. A large deciding vote was to name it Marbury. Pictured is Addison Marbury, to the right of the theodolite in the middle, with some of his surveying team. (Courtesy Samuel C. Linton Jr.)

Peter Jr. and Rosella Huntt Trotter owned Trotter's Hotel in Waldorf. Peter Trotter Jr. is from the second generation of Trotters born in America. His parents came from England and Scotland and were married in Ireland in 1888. Peter and Rosella had eight children, Howard, Lucille, Fred, Ola, Donald, Irene, Anderson, and Thelma. (Courtesy Joyce Simpson.)

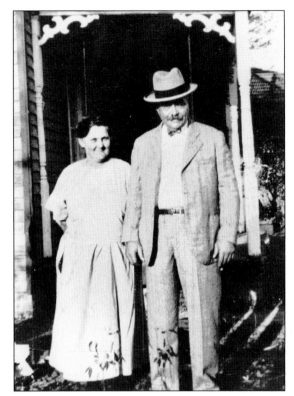

The Trotter children have on their Sunday best clothes to entertain two friends that arrived by horse and buggy. They are standing in front of the Waldorf train station. From left to right are Howard Trotter, Thelma Trotter, Ola Trotter, unidentified, Irene Trotter, Lucille Trotter, and unidentified. (Courtesy Joyce Simpson.)

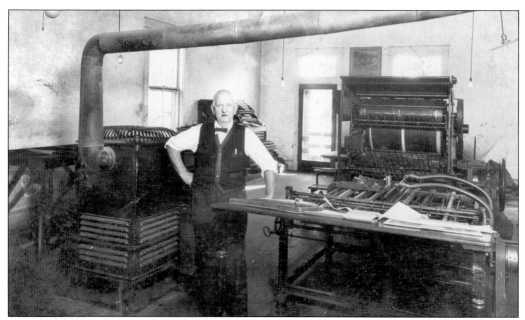

Louis Metcalf Hyde was the printer-editor of the *Times Crescent Newspaper* from 1898 until 1948. He began his apprenticeship as a "printer's devil" (a nickname for printing apprentices) in 1878 with the oldest newspaper in Charles County, the *Port Tobacco Times*. When the *Port Tobacco Times* and the *Times Crescent*, published in La Plata, merged in 1898, Hyde became managing editor. (Courtesy SMSC at the College of Southern Maryland.)

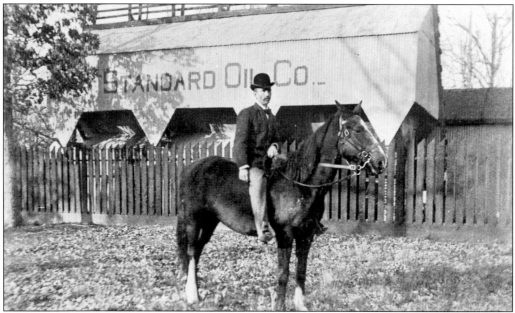

At the end of the 19th century, Ashton Berry was the only representative for the Standard Oil Company, located near the railroad tracks in La Plata. He delivered oil in addition to maintaining the accounting books. The Standard Oil Trust was broken up in 1911, and baby Standard Oil companies like Esso—Eastern States Standard Oil—became more valuable than the parent company. (Courtesy SMSC at the College of Southern Maryland.)

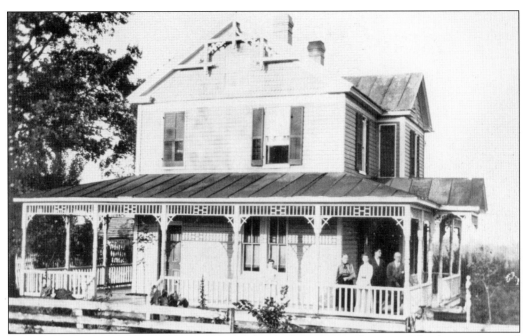

In La Plata, William T. Maurice was the first home decorator and painter. This house, pictured in 1906, was on St. Mary's Avenue and painted gray on the outside and accented by white trim and yellow gables. It was also one of the few homes to have indoor plumbing that included a sewage removal system. (Courtesy SMSC at the College of Southern Maryland.)

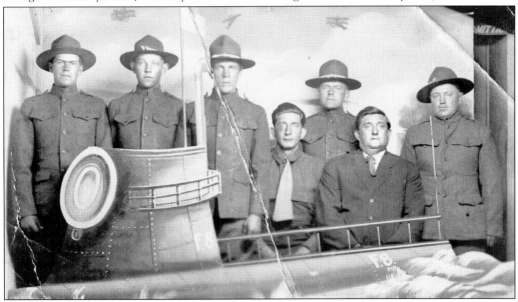

World War I began in 1914 and involved 36 countries. In 1916, volunteers from Waldorf joined France to fight Germany. From left to right are unidentified, Howard Trotter, two unidentified volunteers, Jerry Mudd, unidentified, and Benson Gates. Despite machine guns, gas, mines, aerial warfare, and torpedoes, all returned home. Howard Trotter became a mechanic at his brother's Pontiac agency. Benson Gates became a partner in the Hamilton and Gates Restaurant. (Courtesy Joyce Simpson.)

In the summer of 1915, the Marshall family had a picnic on the grounds of Marshall Hall Amusement Park. From left to right are (first row) Sara Compton Warren, Albert Warren, Sydney Brawner, Bill Wayland, and Elinore Warren; (second row) Douglas Marshall (owner of Marshall Hall Park), Maggie Hodges, John Warren, Rachal Warren, William P. Jameson, Katie Marshall (wife of Douglas), and Carroll McWilliams. (Courtesy Highby, Marshall Hall Collection at the SMSC at the College of Southern Maryland.)

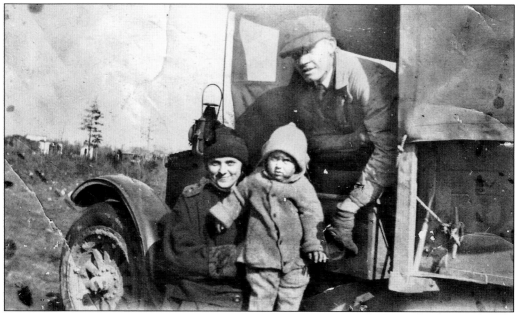

Carlton Bean, pictured with wife Ola Trotter Bean and son Robert Elliott, was a rural-route mail carrier out of the Waldorf post office from 1919 until 1930. Carlton used his own vehicle to carry the mail. The postmaster at Waldorf in 1919 was Edward G. Berry, followed by Phillip E. Huntt. (Courtesy Joyce Simpson.)

Robert Crane was a native Charles Countian who became a political leader in Maryland. He formed the Cobb Island Development Company with F. B. Bannister and Company of Baltimore as agents. They purchased Cobb Point in 1918 and renamed it Cobb Island. By 1922, teams of surveyors laid out roads and building lots. Lots ranged in price from $50 to $200. Through Crane's influence with state leaders, he was able to get a road system into Charles County. (Courtesy Dorothy Kitchen Jenkins.)

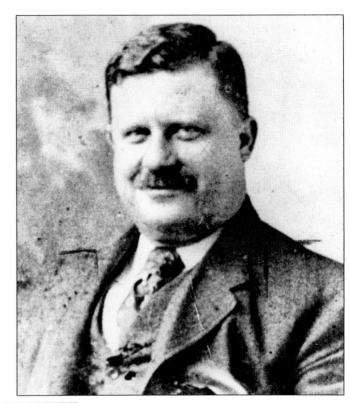

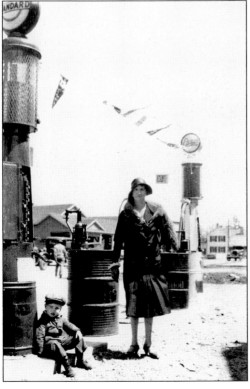

Theresa Olivia Burch Martin was born in Bel Alton in 1893 and became the wife of Central Garage owner Frank Alexander Martin. Theresa was a charter member of the La Plata Women's Club and of the Neale Council, a Catholic Daughters of America organization. Because of her efforts, the town of La Plata laid down their first asphalt streets and put up streetlights. She was the first woman in La Plata to get a driver's license. During World War II, Theresa helped with civil defense by climbing the two-story tower used to spot enemy airplanes and making bandages to send to Europe. She received the town's leading citizen award when the war ended. Miss Priss, as she was affectionately known, liked to dress very well and always wore a hat. She is pictured in front of Central Garage with her son, Joseph Bret Martin. (Courtesy Martin Collection.)

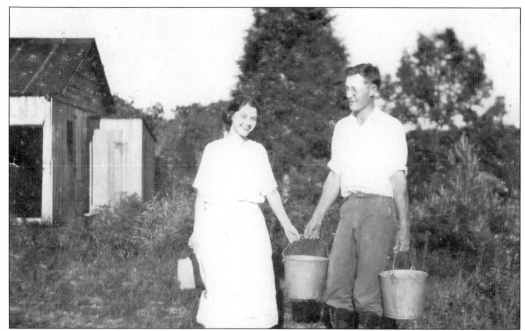

John Dent, brigadier general of the Revolutionary War militia, was gifted the lands of Mount Zephyr in 1753 after his marriage to Sarah Marshall of Marshall Hall. The farm was briefly sold after the Civil War, but restored to the family in the early 1900s, it passed into the Dent lineage when Frank Bolton married Melissa Dement. Frank A. Bolton attends to the milking duties of Mount Zephyr and is joined by sister-in-law Elise Dement in 1924. (Courtesy Sharon Bolton.)

Charles Dement, pictured, was the son of William Luther Dement and Pearl Harris Dement, owners of the W. L. Dement store on the corner of Charles Street and Oak Avenue in La Plata. Luther built the store about 1885–1900 and it remained in the Dement family until the 1950s. It was sold to Barry Cornblatt, an employee, and became Barry's Department Store. (Courtesy Sharon Bolton.)

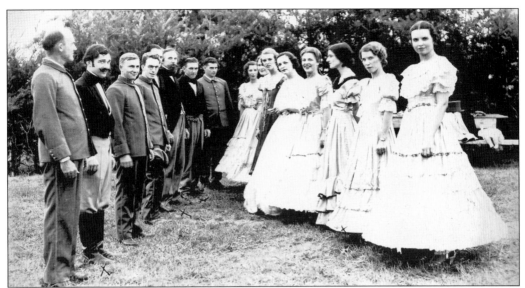

Friends and relatives of Dr. Samuel A. Mudd reenacted the story of John Wilkes Booth's assassination of President Lincoln and the unfortunate country doctor who treated Booth's broken leg in the Charles County Fair of 1935. They are lined up to dance the Virginia Reel. From left to right are Tom McDonough, Judge John Hanson Mitchell, Mitchell Digges, James Craig Mitchell, Frank Hamilton, Bernard Gwynn, Joseph Mudd, Arthur Gray, granddaughter Dorothy Posey, Viola Swan, Betty Mitchell, Mrs. DeSales Mudd, Elizabeth Barnes, Jane Gray, Emily Mudd, and Mrs. E. E. Harbough. (Courtesy Samuel A. Mudd Society, Inc.)

Representing the Mudd family in the 1935 play written by Kathleen Reed Coontz was Bernard F. Gwynn, cousin to Dr. Mudd, portraying the good country doctor. Margaret Berry Brown acted as his wife, Sarah Frances Dyer Mudd. Dr. Mudd called her Frank. The smallest child pictured is Allan Mudd, Dr. Mudd's great-grandson. The other two children are unidentified. (Courtesy Samuel A. Mudd Society, Inc.)

Also in the play, John Hanson Mitchell portrayed John Wilkes Booth. John Mitchell practiced law out of his Port Tobacco office. He was also part of the first planning commission for the town of La Plata and served on the Board of Library Trustees for Charles County. (Courtesy Samuel A. Mudd Society, Inc.)

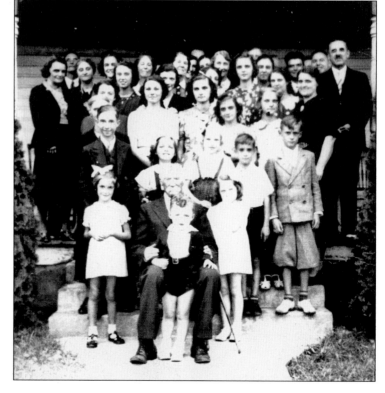

Initially Waldorf was called Bean Station after the nearby village of Bean Town, which was named for the Bean family who occupied the area. The Bean family was one of the founding families that arrived at St. Mary's City by way of the *Ark and Dove*. Pictured is John Henson Bean, sitting, surrounded by his family that celebrated his 90th birthday in 1938. (Courtesy Joyce Simpson.)

The first president of the Cobb Island Citizens Association, formed in 1927, was John H. Kitchen. The Kitchen family would leave Washington, D.C., the day after school got out, and returned the day before school started. He came down with his wife, Mary, and daughter, Dottie. John is wearing the white hat in the middle of the crowd who is watching the festivities at the 1939 Cobb Island Field Day. (Courtesy Dorothy Kitchen Jenkins.)

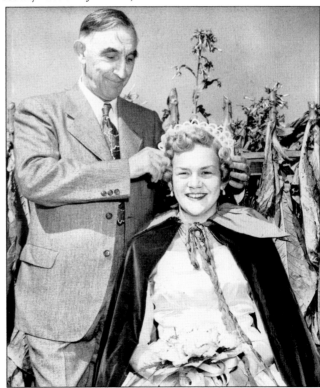

Barbara Lee Farrall was 19 years old when she was crowned the 17th Queen Nicotina in the 1951 Charles County fair. Barbara was crowned at the coronation on the fairgrounds by the Honorable Leroy Pumphrey, member of the House of Delegates for Prince George's County. (Courtesy Barbara Lee Farrall Baldus.)

Joseph Mudd was the grandchild and last family member of Dr. Samuel A. Mudd to live in the home that John Wilkes Booth visited for medical attention to his broken leg after assassinating Pres. Abraham Lincoln on April 14, 1865. The home was sold to the Maryland Historical Trust in 1970 and to the Samuel A. Mudd Society on March 3, 1983. (Courtesy Samuel A. Mudd Society, Inc.)

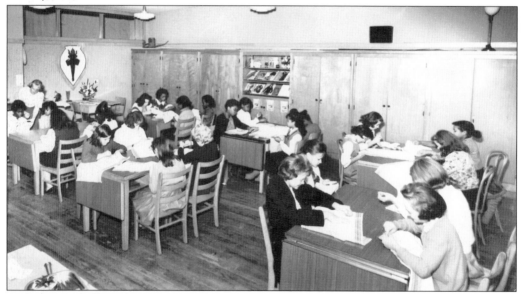

Kathryn Mitchell Cochrane Newcomb was a home economics teacher at Milton Somers Middle School and La Plata High School. "Kittie" retired in 1980 and pursued her love for historic research and preservation full time. Her preservation efforts included the restoration of the Port Tobacco One Room Schoolhouse and Thomas Stone Cemetery. She chaired or cochaired the centennial celebrations for the towns of La Plata and Indian Head, Christ Church's 300th anniversary, and Charles County's centennial celebration. She was historian for the town of La Plata from 1974 to 2001 as well as historian for Christ Church, Port Tobacco Parish. She is pictured on the far left in her classroom at Milton Somers Middle School. (Courtesy Kittie Newcomb Collection.)

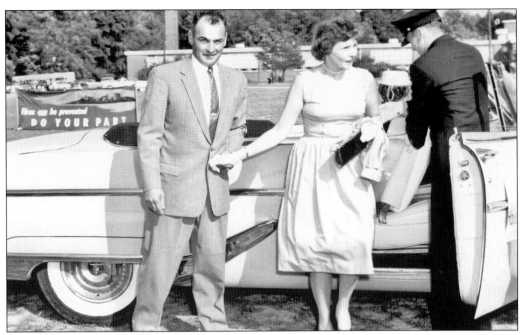

Delegate Samuel C. Linton Jr. and wife Joan Bradford Blake were honored guests at the Fire Prevention parade of 1959 in Indian Head. Joan Bradford Blake was a home economics teacher at Milton Summers School. Delegate Linton served three terms; the first was 1958 to 1966, then from 1983 to 1990, and the last was from 1995 to 2002. (Courtesy Samuel C. Linton Jr.)

At the American Legion Halloween Party of 1961, Mary Jo Hancock, on left, served attendees George Barnes, grand knight of the Knights of Columbus from 1962 to 1963 for the Arch Bishop Neale Council 2279, and his wife. Mary Jo was a writer and photographer for the *Times Crescent Newspaper* and wife of Maryland state attorney John C. Hancock. (Courtesy Kittie Newcomb Collection.)

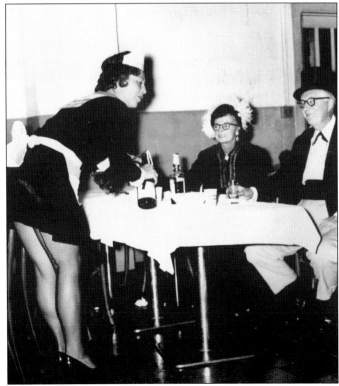

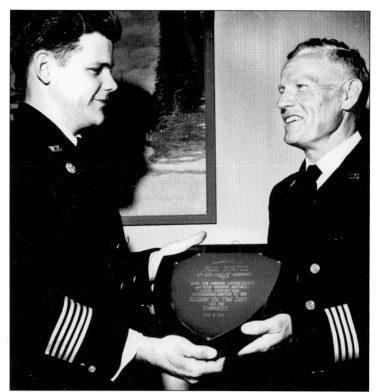

W. Paul Burton (right) moved to Waldorf in the middle 1940s and farmed for 20 years. In 1949, he became a charter member of the Waldorf Volunteer Fire Department (VFD). He was fire captain from 1951 to 1952, becoming fire chief in 1953, serving until 1961. When he stepped down as fire chief, he was made honorary fire chief. The current Waldorf VFD was dedicated to him in 1991. William Cooke (left) is presenting Burton with a plaque for his loyal support and outstanding service. (Courtesy William F. Cooke.)

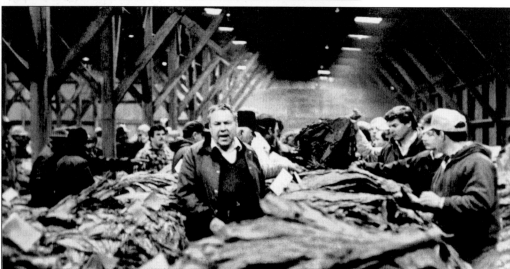

After Francis Jameson "Jimmie" Schultz got out of the U.S. Navy during World War II, he went to work at Edelen Brothers Tobacco Warehouse in La Plata and eventually bought it. In the 1950s, he became a partner in the Farmers Tobacco Warehouse in Hughesville and eventually partnered with Jim Bowling in the Waldorf Warehouse. He became an authority on tobacco production and was appointed by Gov. Spiro Agnew and then reappointed by Marvin Mandel to the Maryland State Tobacco Authority. Jimmie became known as "Mr. Maryland" to those in the industry. This photograph was taken of Jimmie as he worked the rows of tobacco for sale in the Hughesville Tobacco Warehouse. (Courtesy Jane Schultz.)

Five

RECREATION

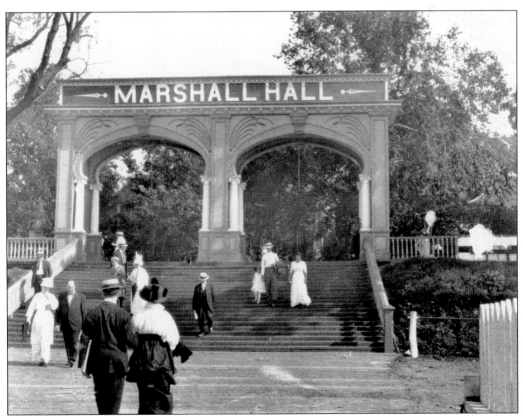

Marshall Hall Park, on the banks of the Potomac River, was once a successful tobacco plantation. It had been the home to generations of Marshalls from the 1730s. Marshall Hall remained in private hands until 1889, when it was bought by the Mount Vernon and Marshall Hall Steamboat Company, then made into a small Victorian park. (Courtesy of Clinton Addison, Marshall Hall Collection at the SMSC at the College of Southern Maryland.)

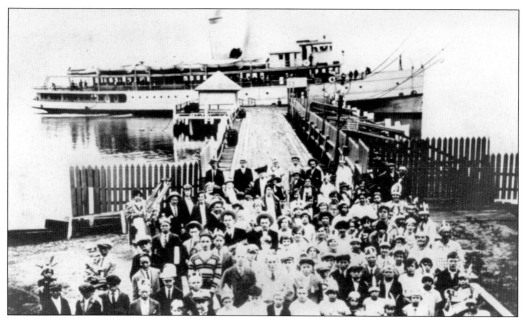

Steamboat service to Charles County, via the Potomac River, started in 1815. By 1820 the Washington, Alexandria, and Georgetown Steam Packet Company established regularly scheduled service to Marshall Point when it was a private home. Pictured is a Sunday school group from Indian Head disembarking at Marshall Hall from the steamer *Porpoise*. (Courtesy Harry Jones, Marshall Hall Collection at the SMSC at the College of Southern Maryland.)

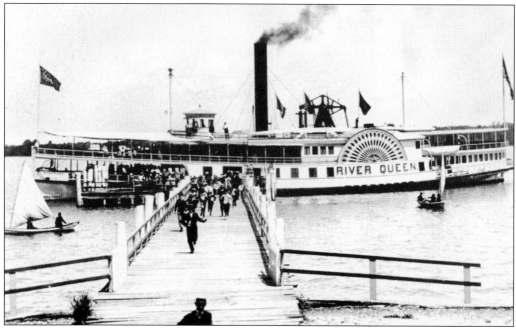

Marshall Hall Park enticed visitors with gorgeous water vistas, picnic tables, a carousel, and dance pavilion by 1910. The running passengers from the *River Queen* steamer shows what a happy place Marshall Hall Park must have been in 1897. (Copyright *Washington Post*; reprinted by permission of the D.C. Public Library.)

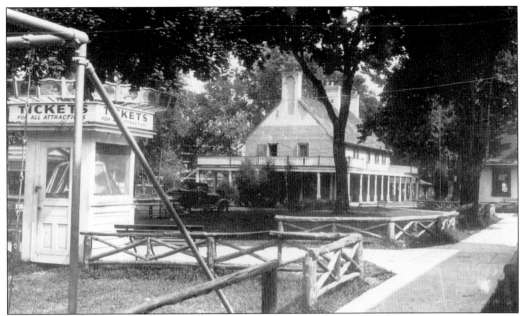

Upon entering Marshall Hall Park in the early 1900s, visitors saw the original, Colonial-style brick home built by plantation owner Thomas Marshall. A ticket booth on the left sold tickets for the carousel, featuring hand-carved wooden horses. The walkway was nicknamed Honeymoon Trail. (Courtesy Clinton Addison, Marshall Hall Collection at the SMSC at the College of Southern Maryland.)

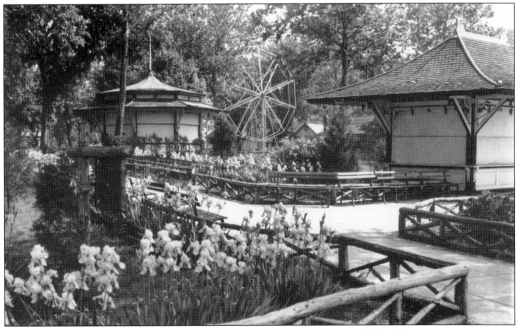

By 1934, Honeymoon Trail was lined by fragrant irises at Marshall Hall Park, and more rides were added, like the Ferris wheel in the middle of the photograph. The building on the far right was the game stand, with games like ring toss. (Courtesy Clinton Addison, Marshall Hall Collection at the SMSC at the College of Southern Maryland.)

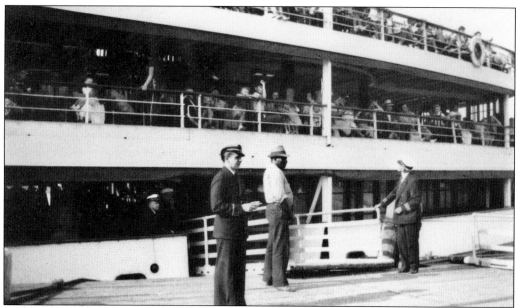

From the Seventh Street wharf in Washington, D.C., the Wilson Line carried passengers to Marshall Hall Amusement Park. This is the *City of Washington* at the Marshall Hall pier in 1933. At the left is purser Albert Chitty, at center is dockhand Ballard Washington, and at right is Herbert Bohannon. (Courtesy Lehman, Marshall Hall Collection at the SMSC at the College of Southern Maryland.)

The Wilson Line owned the excursion boat that shuttled passengers to Marshall Hall and Chapel Point. The Great Depression devastated the business, but the Wilson Line endured by offering tours, dinner, and entertainment cruises on their *City of Washington*. One of the performers was Elvis Presley on March 23, 1956. (Courtesy Clinton Addison, Marshall Hall Collection at the College of Southern Maryland.)

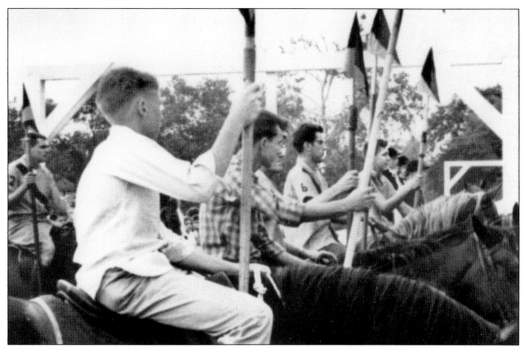

Jousting is one of the oldest equestrian sports in the world. The practice was carried over to the New World by way of the *Ark and Dove*. Pictured are contestants at Marshall Hall in 1955. (Courtesy Lehman, Marshall Hall Collection at SMSC at the College of Southern Maryland.)

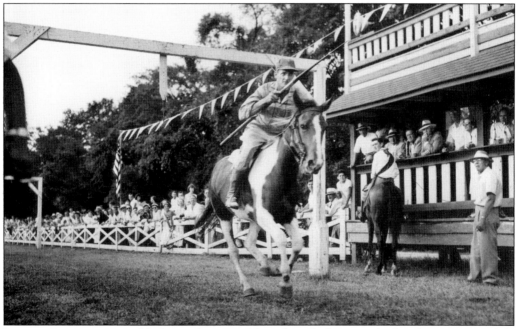

Jousting contestants would charge down an 80-yard track, lance tucked under one arm while holding the reins with the other, to a ring suspended in the air about six feet off the ground. The contestant pictured is at Marshall Hall in the 1940s. (Courtesy Margaret Addison, Marshall Hall Collection at the SMSC at the College of Southern Maryland.)

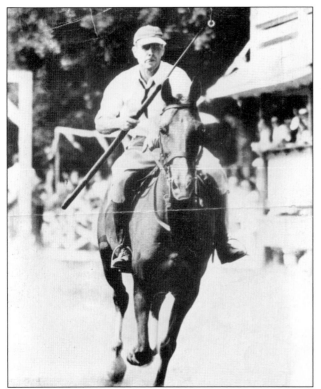

The jousting contestant is just about to spear the first ring of three to win the prize of naming the tournament's queen. If there is a tie, the rings will be replaced with smaller ones until a champion emerges. Jousting became the official state sport of Maryland in 1962. The contestant pictured is at Marshall Hall in the 1940s. (Courtesy Addison Clinton Collection.)

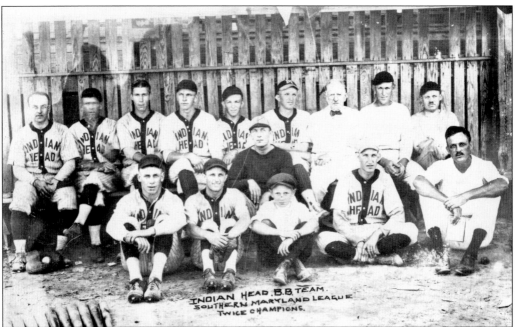

Hardball in Southern Maryland got started around 1920. By 1922, Indian Head's baseball team were twice champions of their league. There were no sponsors to provide uniforms, gloves, or steel spikes; a hat was passed to the fans in the bleachers for donations. Indian Head's number-one rival was the town of La Plata. (Courtesy SMSC at the College of Southern Maryland.)

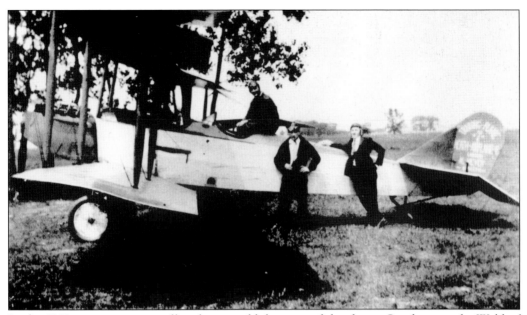

In the 1930s, a two-seat propeller plane would drop out of the sky on Sundays to take Waldorf locals on a short flight for $2. It would land on Jennings Hamilton's farm, where Checkers fast-food restaurant and Jaycees Hall now are. Route 301 wasn't built yet. (Courtesy SMSC at the College of Southern Maryland.)

Movies at the Waldorf Theater in the 1940s cost 10¢ during the week and 25¢ on Saturday, when two features were run back to back. The theater wasn't air-conditioned and only had a pull-handle vending machine for candy. When movies weren't playing, stage shows like Roy Rogers and his four-man band, the Sons of the Pioneers, would entertain. (Courtesy SMSC at the College of Southern Maryland.)

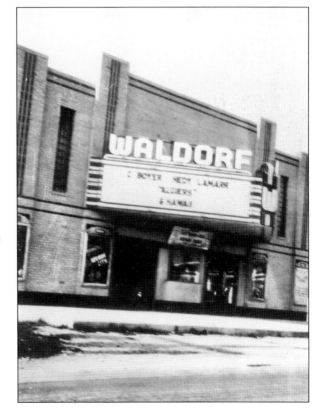

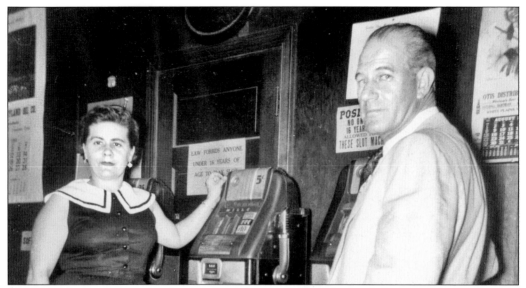

In 1949, Charles County legalized slot machines, and hundreds of thousands traveled to the area not only for the beaches and amusement parks but also for the one-armed bandits. Slot machines arrived in Charles County by way of the steamboats that docked at the various piers and wharves in the county in the 1920s. Legalization by 1950 brought millions in revenue to the county through licensing fees. In 1963, the Maryland Assembly voted to get rid of them and called for a five-year phase-out. The couple pictured is playing a 5¢ machine that paid a $10 jackpot at Hamilton and Gates Restaurant in Waldorf. (Courtesy SMSC at the College of Southern Maryland.)

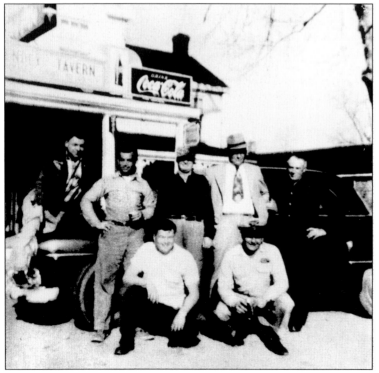

In the 1950s, Friendly Tavern was popular as a neighborhood watering hole for the working class. Pictured from left to right are (first row) Gerald Hamilton and Donald Hamilton; (second row) unidentified, Wallace Montgomery, Bobby Pearson, and two unidentified. The building was once occupied by the first store in Waldorf, the Howard and Berry store. (Courtesy SMSC at the College of Southern Maryland.)

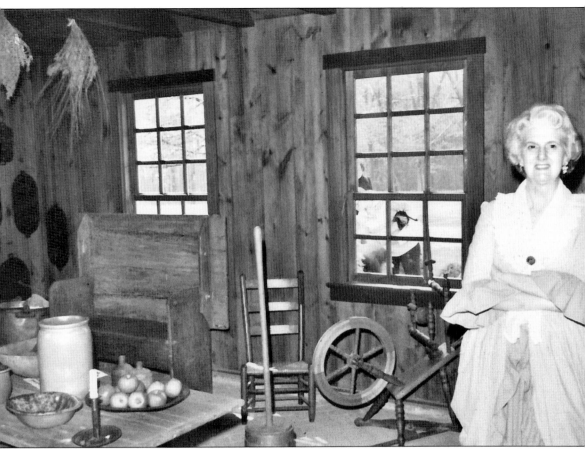

The Colonial tobacco plantation of Maj. Gen. William Smallwood became a historic park in 1958. General Smallwood was a Revolutionary War officer, and as the fourth governor of Maryland, he helped to ratify the federal Constitution. In this photograph, costumed docent Kittie Newcomb is explaining some of the Colonial crafts displayed. (Courtesy Kittie Newcomb Collection.)

Before one of the many storms that changed the geography of Cobb Island, there was a beach on Neale Sound in the late 1950s near Shymansky's Restaurant. The Cobb Island Bridge is in the background of the photograph and is known by locals as the Rainbow Bridge. Nancy Jenkins is the girl standing with the towel in her hands. (Courtesy Dorothy Kitchen Jenkins.)

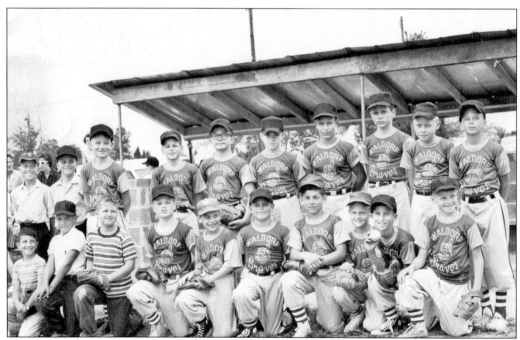

The Waldorf Braves formed their baseball team from students attending St. Peters School. This photograph was taken of the team in the 1960–1961 season. In the first row on the far right is Joe Potter; John Simpson is left of him. Donnie Potter is far right in the second row. The coach was Lawrence Potter; the assistant coach was Ray Simpson. The Southern Maryland Little League included the towns of Waldorf, La Plata, Indian Head, Hughesville, and Glasva. (Courtesy Joyce Simpson.)

Steamed crabs at Popes Creek on the Potomac became popular in the 1960s. Pictured cooking crabs is Connie Butler at Robertson's Seafood Restaurant. The pot is made from an oil drum and held dozens of crabs at a time. Robertson's was once called Captain Drinks, opened by Paul Drinks. It was left to David Drinks, who eventually passed it onto Billy Robertson, a nephew. (Courtesy Society for the Restoration of Port Tobacco.)

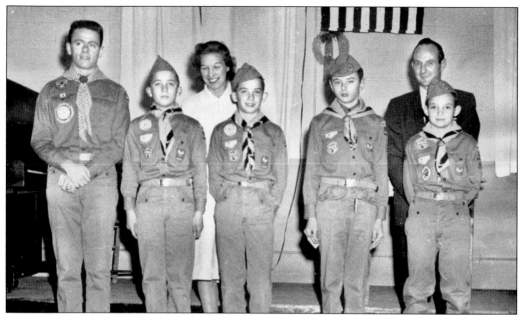

Boy Scout Troop 419 was restarted in 1960 by institutional representative Ray Simpson, pictured back right. The Lions Club was the first sponsor, and Moses J. Moses was the first troop leader. Pictured from left to right are John McDermott, Steve Miller, Charlotte Miller, Phil Miller, Billy Moore, and Tommy Simpson. (Courtesy Joyce Simpson.)

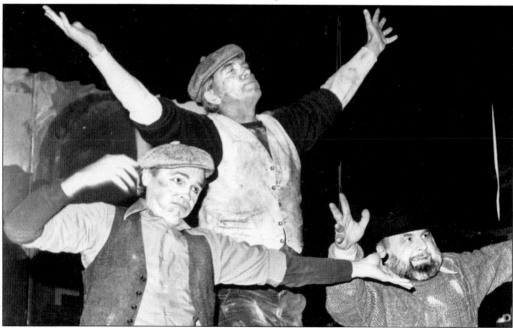

Friends for the benefit of building a replica of the Port Tobacco courthouse started the Port Tobacco Players theater group in 1948. They played in schools, fire departments, and wherever they could. In 1974, they moved to their permanent location on Charles Street. In the photograph, left to right, Joe Carvajal, Gordon O'Neill, and Quick Carlson are starring in *My Fair Lady*. (Courtesy Bridgett and Gordon O'Neill.)

Six

EDUCATION

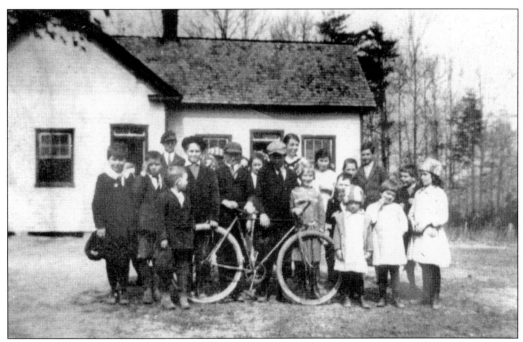

Newburg Two-Room School was built in the early 1900s. One room was for desks and the other was used as a playroom and cloakroom. The trustees of the school supplied the wood for the stove, and either the teacher or first boy to arrive started it. Their athletic equipment was comprised of a dodge ball and a baseball made from saved string. One of the patrons made the bat. (Courtesy SMSC at the College of Southern Maryland.)

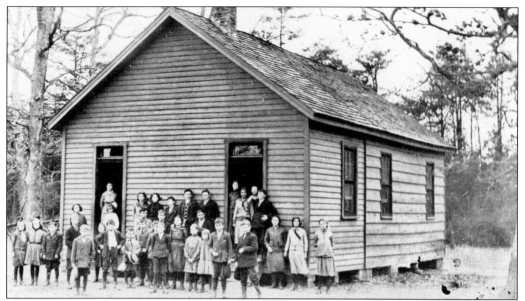

The Pomfret School had desks with a seat attached to the front. Two children were assigned to each seat, girls with girls and boys with boys. Their ages ranged from 5 to 17. It was not uncommon for some students to repeat grades since they were pulled out of school to help with farm work. The Webster Dictionary was used as a textbook. George Washington's birthday was not a holiday, but usually meant more work in the form of a composition on the father of this country. (Courtesy SMSC at the College of Southern Maryland.)

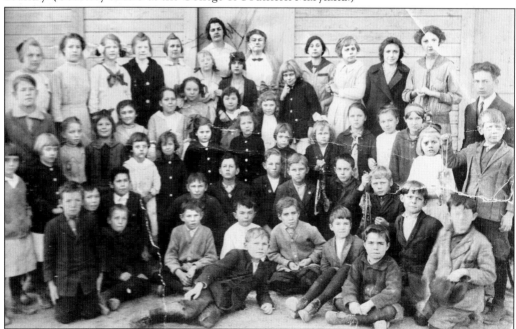

In the second decade of the 20th century, Waldorf school children outgrew the one-room schoolhouse located on Route 5 and what is now Post Office Road. The new, two-room schoolhouse was built in the 1920s on Berry Road, where the Barley Building is now. It accommodated grades one through eight. (Courtesy Joyce Simpson.)

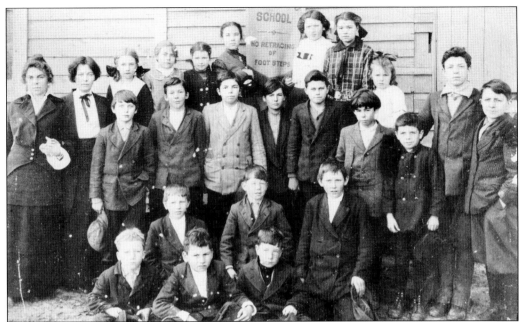

The Crossroads School got its name from two main roads, Route 6 and Liverpool Road, intersecting near Nanjemoy. The words on the banner under the school name say "No Retracing of Foot Steps." This photograph was taken about 1912 of half the student body that usually attended. Pictured from left to right are (first row) Chester Murphy, Grover Davis, and Barry Gilroy; (second row) James Wright, Bernard Gilroy, and Carl Wright; (third row) Charles Adams, Herbert Henderson, Victor Henderson, Roland Scott, Robert Perry, Bertram Davis, Abner Perry, Wilton Maskel, and Steve Kendrick; (fourth row) teacher Lillie Gray, teacher Zelda Norman, Pearl Murphy, Anna Willet, Olive Kendrick, Lollie Bowie, Willetta Wright, Marie Kendrick, and Pearl Wright. (Courtesy SMSC at the College of Southern Maryland.)

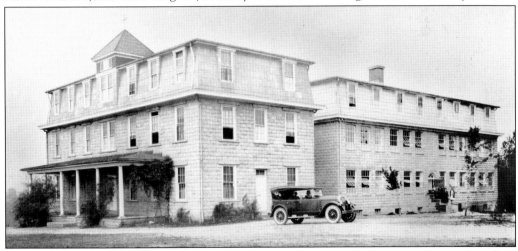

The three-story Notre Dame High School in Bryantown was built in 1915. The first floor was for grades one to eight; the second floor was for high school. The third floor was sleeping quarters for boarders from Baltimore and Washington, D.C. Education at this site started in 1859 as St. Mary's Institute, an academy for young ladies. (Courtesy SMSC at the College of Southern Maryland.)

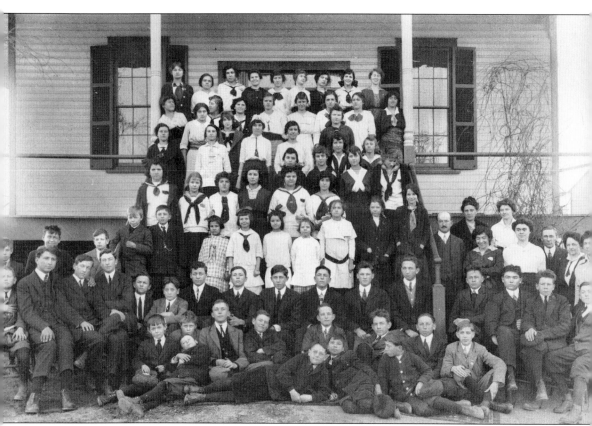

McDonough Institute was the first school to include the higher grades in Charles County. Prior to it, one- and two-room schoolhouses only went to the eighth grade. McDonough Institute was named after Maurice McDonough, traveling salesman and benefactor of the county's earliest school system. The photograph shows all grades attending the school in 1925. (Courtesy SMSC at the College of Southern Maryland.)

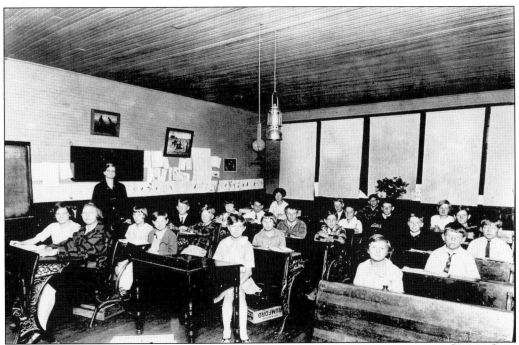

On November 9, 1926, La Plata Elementary School had 60 students in attendance when a tornado demolished the school, killing 13 children. Some survivors were carried hundreds of feet before the swirling vortex let them go. Since there was no hospital nearby at the time, victims were driven to Providence Hospital in Washington, D.C. On December 3, 1926, the school resumed classes in town hall. (Courtesy SMSC at the College of Southern Maryland.)

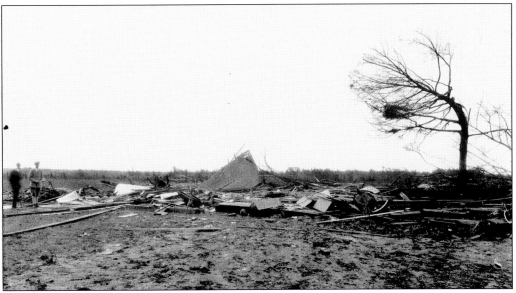

Debris from La Plata Elementary School after the tornado of November 9, 1926, was carried as far away as the town of Bowie, Maryland, which was about 30 miles from the school. Some good citizens, and the La Plata PTA, demanded that instead of a new two-room school, a consolidated elementary and high school be built. (Courtesy SMSC at the College of Southern Maryland.)

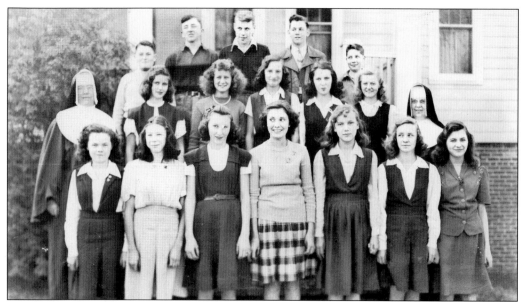

The Jesuits of Sacred Heart Parish started Sacred Heart High School in 1927. A mother superior and priests headed the school board. There was no air-conditioning, and a potbellied stove was the only source of heat in the classrooms. Dances, musical recital, plays, and the prom were held in Brent Hall. This photograph is the freshman class of 1946. (Courtesy SMSC at the College of Southern Maryland.)

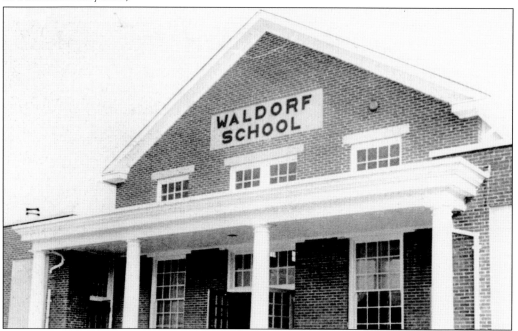

A Friends of Old Waldorf School Foundation was incorporated and begun in 1994 to rescue the last remaining public building in Waldorf. There were four classrooms that accommodated grades one through seven. In the 1950s, a few more classrooms were added, as well as a cafeteria. High school students had to attend La Plata when they graduated from Waldorf School. (Courtesy SMSC at the College of Southern Maryland.)

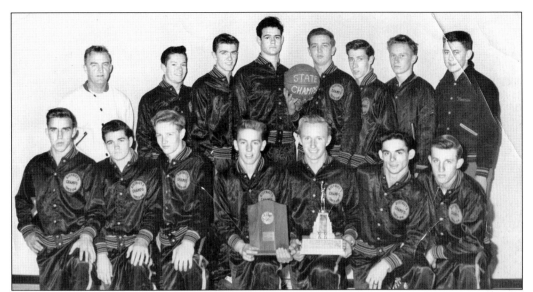

This photograph was taken at the second Lackey High School, located in Glymont, of the boys' basketball team of 1954–1955, who were the Class C State Champions. At the time, the school had approximately 80 boys attending. Pictured from left to right are (first row) Tommy Bailey, Jack Bowie, Eddie Gawthrop, John "Buddy" Sprague, Freddie Frix, Jimmy Quinlan, and Addison "Jeep" Townes; (second row) Coach Frank LaFontaine, John "Chuck" Simmons, Terry Bernard, Charles "Speedy" Weeks, Bruce Maynard, Linden "Pete" Welch, George McGuigan, and Maurice "Hop" Hopkins. (Courtesy Bernard Collection.)

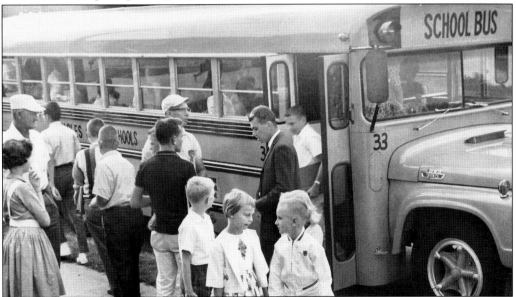

Barnsley Warfield, principal of Milton Summers School, would greet his students at the bus stop every day in the 1960s. At that time, grades 1 through 12 attended and would all ride the school bus together. Warfield then became the principal at Bel Alton for a short time and then served as principal of La Plata High School. Chatting in the foreground are two younger students, John Newcomb and Karen Stump. Barnsley Warfield is directly behind in the dark suit. (Courtesy Kittie Newcomb Collection.)

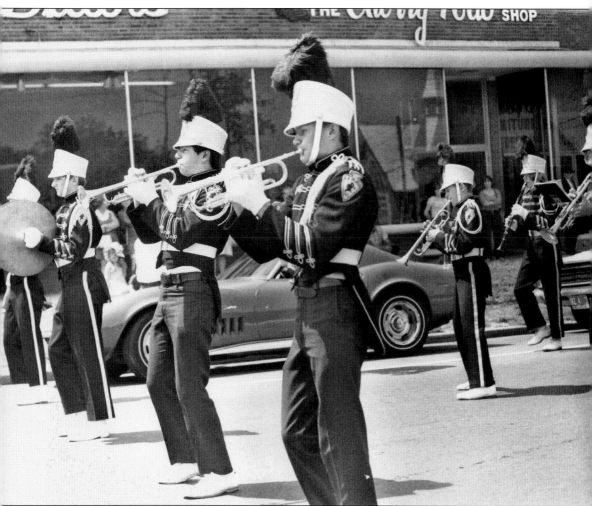

One of the biggest school bands in the 1970s in Charles County was La Plata High School. There were approximately 45 musicians and 22 color guard. Under conductor Ronald Braithwaite, they played every weekend during football season and sometimes in a Fourth of July or Memorial Day parade. This photograph was taken in a parade in Waldorf. The band members from left to right are (first row) John Newcomb (cymbals), Bill Foreman (trumpet), and unidentified (trumpet). (Courtesy Kittie Newcomb Collection.)

Seven

CHURCHES

Started by the Jesuits in 1641, St. Thomas Manor and St. Ignatius Catholic Church remains one of the oldest parishes in continuous service in the United States. Fr. Andrew White, who arrived on the *Ark and Dove* in 1633, was the first priest to settle here on the bluff overlooking the Potomac River and Port Tobacco Creek. He successfully ministered the Word of God to the Potobac and Piscataway Indians. The queen of the Potobac Indians and her tribe were converted and baptized before the English crown had White arrested and sent back in chains. Fr. Thomas Copley joined him shortly before that happened. During his ministry to the Potobac Indians, Father White learned their language and wrote a dictionary. In 1649, the Jesuit residence, St. Thomas Manor, received its name after Father Copley put it in the name of a prominent parishioner, Thomas Matthews, for safe keeping from the English crown and the uncertain politics in the new colony. The property consisted of 4,000 acres and stretched down to the Potomac River. (Courtesy Society for the Restoration of Port Tobacco.)

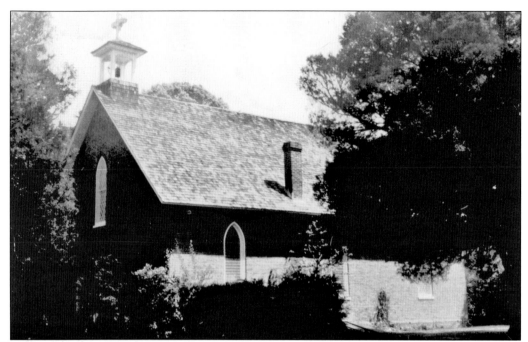

Christ Church in Wayside was part of a new William and Mary Parish formed in 1692. However, there was already an established church here known as the Picawaxon Parish. Tithes were paid in tobacco. Union troops occupied it during the Civil War. It has been repaired and remains to the present. (Courtesy SMSC at the College of Southern Maryland.)

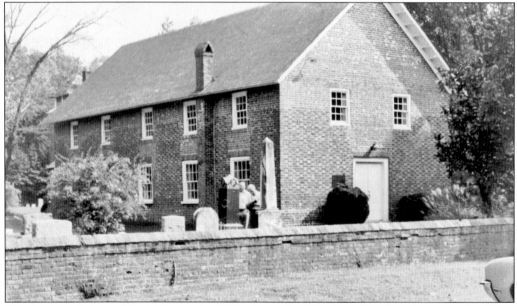

The Durham Episcopal Parish began in 1692 at Ironsides. The first church built was made of logs. A sundial beside the walk would tell parishioners if they were late for the 11:00 service. The first pastor was Rev. John Turling. In 1732, the brick building in the picture was built. Parishioners were assessed 32,000 pounds of tobacco to begin work, and two years later, 16,000 pounds more were assessed to complete it. (Courtesy SMSC at the College of Southern Maryland.)

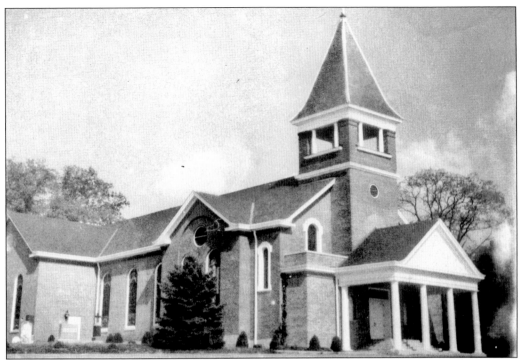

Franciscan fathers came to Charles County and began to care for the spiritual needs of those around the Bryantown-Newport area in 1672. Before the first church for St. Mary's Parish was built in 1697, the Catholic faith was persecuted, and it was thought that chapel services were held in the private chapel of Maj. William Boarman at his plantation, Boarman's Rest. (Courtesy SMSC at the College of Southern Maryland.)

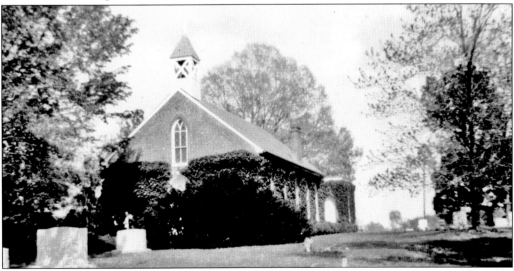

Trinity Church serves members of the Trinity Parish, which encompasses the Hughesville, Bryantown, and Benedict area. The parish was organized in 1744 and received its first full-time clergyman in 1751, Rev. Isaac Campbell, who served for 33 years. There were two churches before the one pictured, which was built in 1769. (Courtesy SMSC at the College of Southern Maryland.)

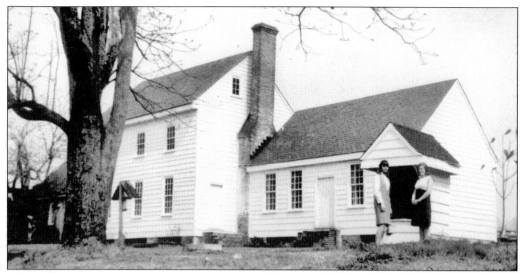

Before the America Revolution, any woman of the Catholic faith wanting to become a nun had to travel to Belgium, France, or Holland for service. Soon after the United States declared their freedom, Fr. Ignatius Matthews wrote to his sister in Holland, Mother Bernardina Matthews, to come home to Charles County to open an order. Mother Matthews came in 1790, accompanied by her two nieces, Mary Aloysia and Mary Eleanora, and Sister Clare Joseph from England. Together they started the first Carmelite monastery in the United States. The photograph is of Mount Carmel restored in 1935, but the young ladies are unidentified. (Courtesy SMSC at the College of Southern Maryland.)

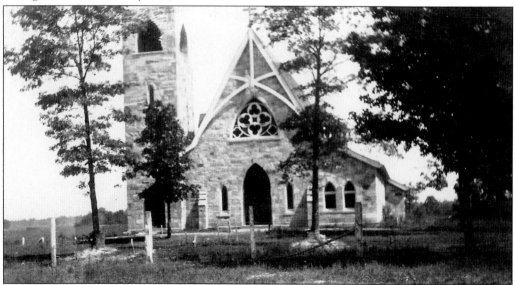

The stone facade of Christ Church on Charles Street in La Plata was moved here by oxcart from the town of Port Tobacco in 1904. When the Popes Creek Railroad Line came through in 1873, the town of La Plata quickly became a bustling boomtown. More businesses from Port Tobacco began relocating to La Plata, and the entrepreneurs built homes there. When the new courthouse was built in La Plata, the church followed and was rebuilt in the same proximity to the courthouse that it was in Port Tobacco. A fire destroyed the interior in 1906. When it was refurbished, a Gothic bell tower was added. (Courtesy Sharon Bolton.)

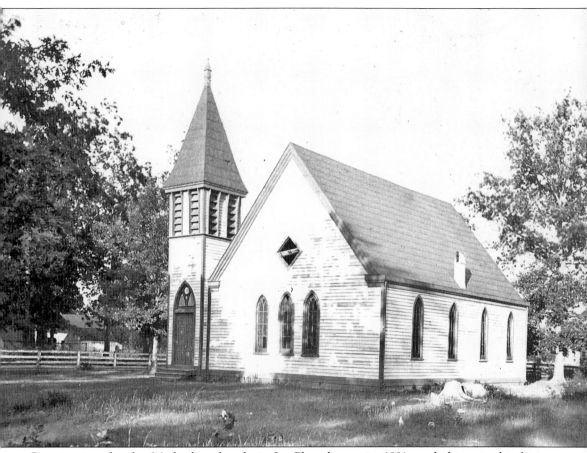

Construction for the Methodist church in La Plata began in 1891, and this was the first denomination to build in the quickly growing town. The new church was named the John B. McFerrin Memorial Church after a local pastor who preached the gospel for over 60 years. The fund-raising venues of choice for the Methodist Ladies were festivals and picnics. The church stood where the Social Services building is today. (Courtesy Sharon Bolton.)

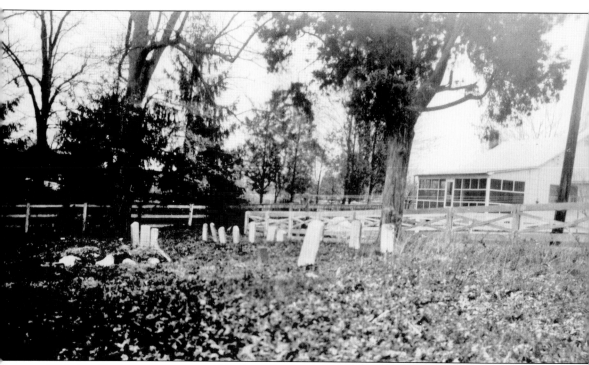

This is a Quaker cemetery near Hughesville that holds 13 tombstones. The Quaker's Society of Friends religious group in Charles County was known as the Pickawaxen Meeting, which began in 1686. Quakers met with great resistance to their faith because of their staunch opposition to slavery. Their strict rules thinned their numbers considerably, and many of them drifted into the Methodist faith. (Courtesy SMSC at the College of Southern Maryland.)

Eight

EVENTS

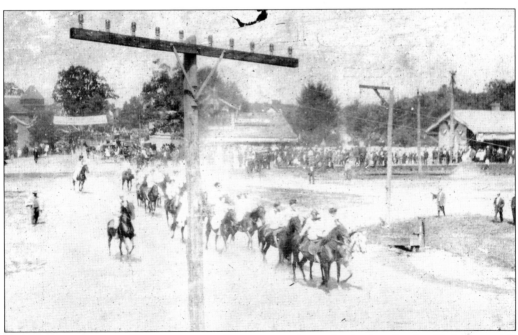

The La Plata Jousting Tournament was first organized as a fund-raiser for the Catholic parish in La Plata to build a church. It featured a parade down Charles Street and a jousting contest held at the fairgrounds. The victor could crown the queen of love and beauty of his choice. This photograph was taken about the late 1800s to early 1900s. The La Plata train station is on the far right with observers lined up on the platform. (Courtesy Sharon Bolton.)

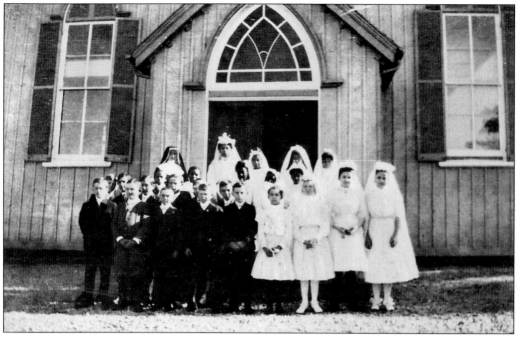

Receiving Holy Communion for the first time is a memorable occasion. Girls wear white and boys wear black suits with crisp white shirts to commemorate their spiritual purity when taking the sacraments for the first time. These children are in front of St. Peter's Catholic Church in 1906. The church, built in 1860, is located on St. Peter's Church Road in Waldorf. Ola Trotter is on the far right. (Courtesy Joyce Simpson.)

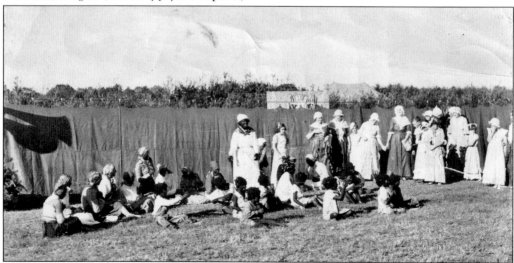

The Charles County Fair of 1932 depicted an important event in county history, the 1892 burning of the Port Tobacco Courthouse. A papier-mâché likeness was created, then set on fire the evening of the last day of the fair. The children pictured sitting down were part of the cast of characters used to retell the story; they are Caucasian children from Waldorf Elementary School with wigs, face paint, and black stockings to depict African Americans. The woman standing in the middle of them is their teacher, Lucille Bowie, also portraying an African American. (Courtesy Joyce Simpson.)

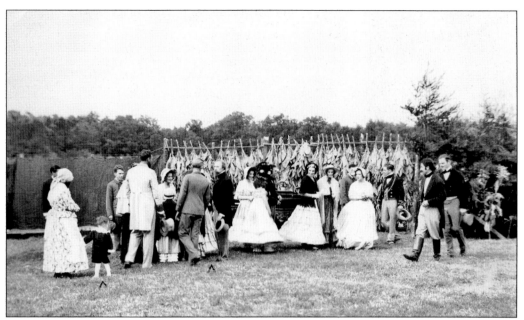

Sen. George L. P. Radcliffe crowned the third Queen Nicotina, Eleanor Digges, daughter of the late Chief Judge W. Mitchell Digges, at the Charles County Fair of 1935. The master of ceremonies began his introduction of the festivities by saying, "This afternoon, my pipe calls forth Dr. Mudd, simple doctor, and victim of the Lincoln tragedy." Thirty-four close friends and leading citizens retold Dr. Mudd's story in 10 scenes. (Courtesy Doctor Samuel A. Mudd Society, Inc.)

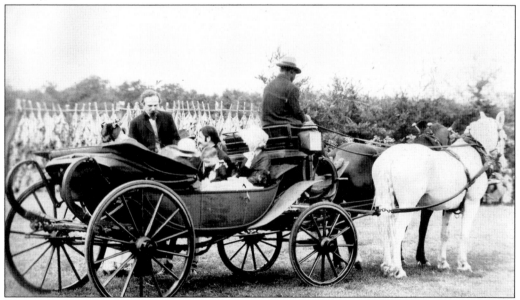

During the reenactment of the Dr. Samuel A. Mudd story, a carriage belonging to his nephew, Walter Mudd, was used. The man standing up at the side of the carriage is Bernard F. Gwynn, cousin of Doctor Mudd, who portrayed the doctor. The young boy seated in the carriage is Allan Mudd, great-grandson of the doctor, who portrayed the Mudds' youngest child at the time, Samuel A. Mudd II. (Courtesy Doctor Samuel A. Mudd Society, Inc.)

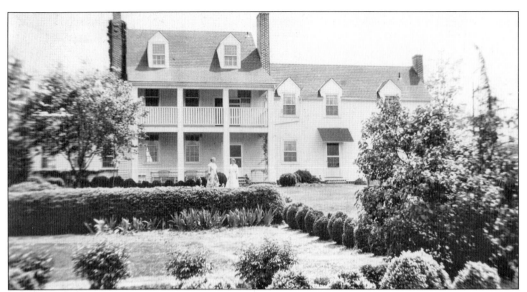

In 1936, Charles County made its debut on Maryland's House and Garden Pilgrimage. In 1938, the Charles County Garden Club was born, and in 1940 it became part of the Federated Garden Clubs of Maryland. Pilgrimage time in Charles County is when homes and gardens, and more importantly, great historic homes and gardens are put in perfect order for a day of visitation by friends and neighbors in the spring. The home and garden pictured is Yatten, built in 1830 near Morgantown. (Courtesy Society for the Restoration of Port Tobacco.)

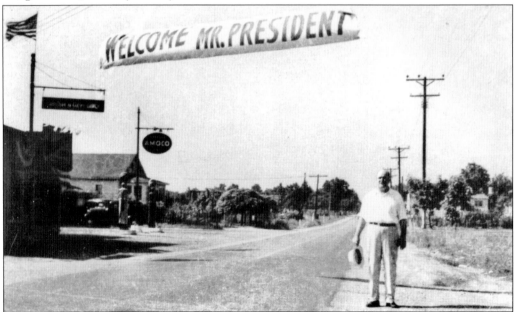

This friendly sign greeted Franklin Delano Roosevelt as he traveled down Route 3 through Waldorf on his way to the bridge commencement ceremony for the Harry W. Nice Memorial Bridge in 1938. Until the bridge was finished, a ferry would carry cars and passengers from Old Ferry Farm across the Potomac to Virginia. Jennings Hamilton, co-owner of Hamilton and Gates Restaurant in Waldorf, is under the welcome sign. (Courtesy SMSC at the College of Southern Maryland.)

The first annual Cobb Island Field Day was held in 1939. Speakers at the festivities were State senator Joseph A. Wilmer, the Honorable Kent R. Mullikin, Hon. Rudolph A Carrico, and Wallace Florance. There were 26 events including a fat man's race for ages 60 and up for 30 yards, a liar's contest with a three-minute time limit, and a husband-calling contest. There was also a bathing beauty contest for girls ages 16 to 25. The winner for that year was Dottie Kitchen, pictured at her family's home on Neale Sound. (Courtesy Dorothy Kitchen Jenkins.)

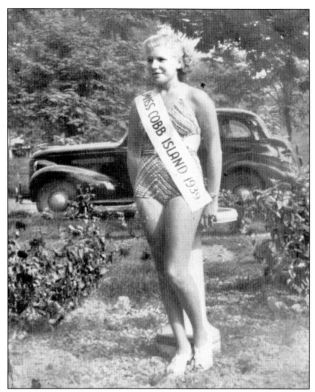

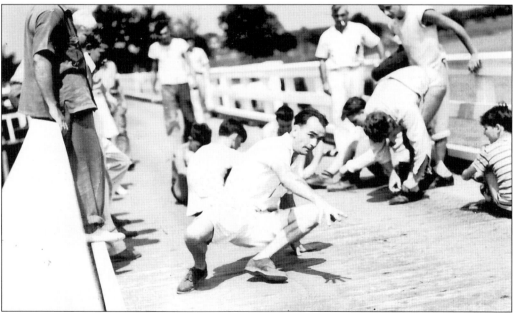

Also featured at the first field day on Cobb Island were races of all kinds, the potato race, sack race, egg race, and shoe race. This photograph is of the shoe race, where the contestants' shoelaces were tied together and they had to run down the 200-foot-long boardwalk. Pictured in the foreground getting up is Charlie Blaine. Against the railing on the right is Bennie Blaine, organizer of the races. (Courtesy Dorothy Kitchen Jenkins.)

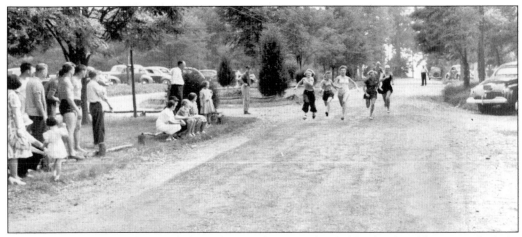

Pictured is a foot race of 60 yards for girls 16 and over at the Cobb Island Field Day. In the light swimsuit is Dottie Kitchen, who won the race. After finishing the race, she entered the girl's 50-yard free-style swimming race, won that, jumped out just in time to enter the bathing beauties contest and won that too. (Courtesy Dorothy Kitchen Jenkins.)

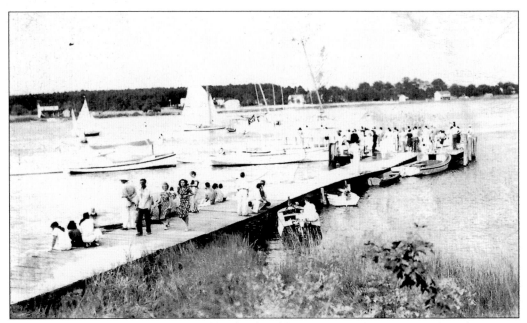

There were four boat races at the Cobb Island Field Day: a motorboat race, outboard race, 16-foot converted rowboat race, and a sailboat cup race. Only one passenger was allowed in the 16-foot converted rowboat, and the outboard motor could not be more than five horsepower. Spectators are watching the sailboat race from the community boardwalk. The boardwalk was where the current bridge was positioned in 1933. (Courtesy Dorothy Kitchen Jenkins.)

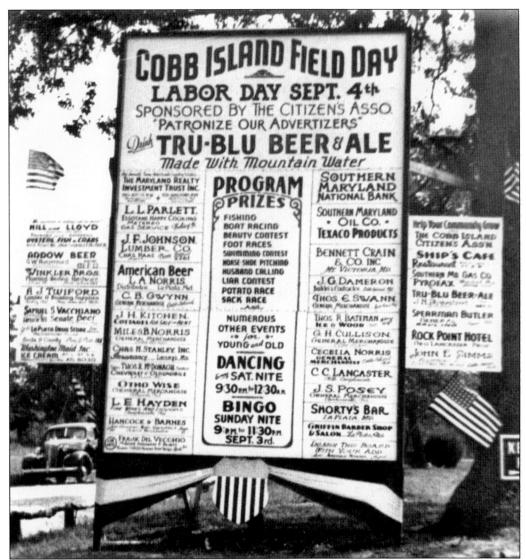

The Cobb Island Field Day was always held on Labor Day. This is an early advertising board, but as years passed, the signs grew three times bigger to accommodate all the sponsors. Businesses from all over the county were represented at these games. (Courtesy Dorothy Kitchen Jenkins.)

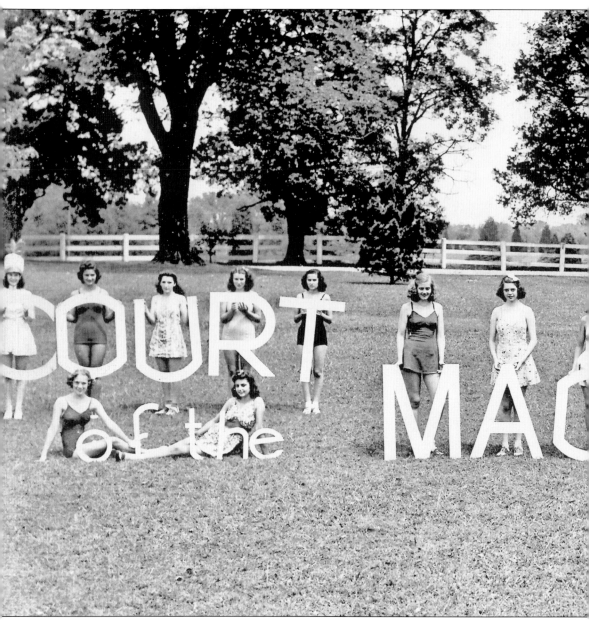

For the Charles County fair in 1941, Gov. Herbert R. O'Conor made funding available from the state to promote the Gold of the Province for a carnival entitled, "While a Cigarette Burns." The pageant featured enormous live stage shows with professional and local talent. Each scene publicized one of the major cigarette brands. The Charles County episode was entitled "Jim Smokes a Chesterfield," in which local citizen Russell Levering played the Chesterfield Gentleman. Senorita Maria Theresa Escalante was chosen as Queen Nicotina. Nicotina is the

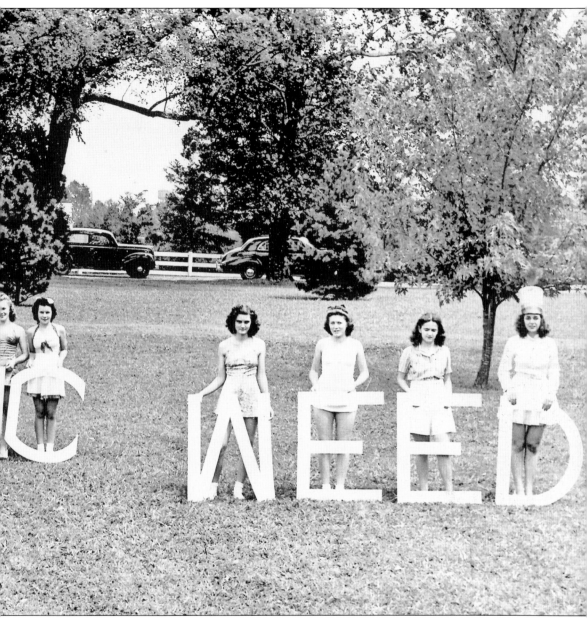

shortened version of the Latin name for tobacco, *nicotiana*. From the fair's beginning, the pageant was known as the Court of the Magic Weed. Tobacco was nicknamed magic weed for its ability to soothe the nerves. The girls in the photograph are duchesses from Maryland, Connecticut, Washington, D.C., Georgia, North Carolina, and Virginia and Princesses from all the southern counties of Maryland and Baltimore City. (Courtesy Kittie Newcomb Collection.)

During the big pageant of 1941 at the Charles County Fair, Senorita Maria Theresa Escalante from South America was chosen as Queen Nicotina. She may be the lady wrapped in tobacco leaves, or it was a hired model. No one is certain. The majorettes around her are unidentified, with the exception of the last girl on the right who is Kittie Cochrane. (Courtesy Kittie Newcomb Collection.)

When Charles County men were notified for selective service, they reported to the draft board located in the Mitchell Building, now D. H. Steffens Building, in La Plata. After reporting, they went to the Fifth Regiment Armory in Baltimore for a physical exam. If they were called upon, they had three days to report to Fort Meade. This photograph is of the men called to duty in La Plata during World War II. They met outside between the courthouse and Christ Church. (Courtesy SMSC at the College of Southern Maryland.)

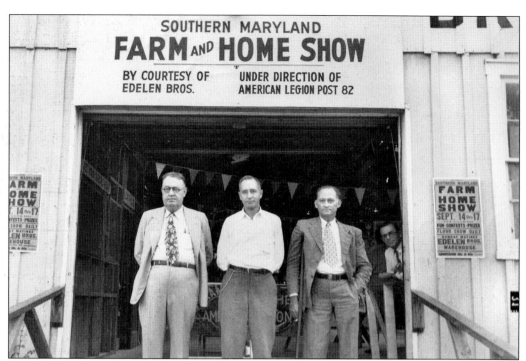

Edelen Brothers Warehouse in La Plata hosted the Southern Maryland Farm and Home Show, which was a fund-raiser for the American Legion Post 82, also in La Plata, in the 1940s. From left to right are Robert Jameson, owner; unidentified; and Gus Cooksey. (Courtesy Jane Schultz.)

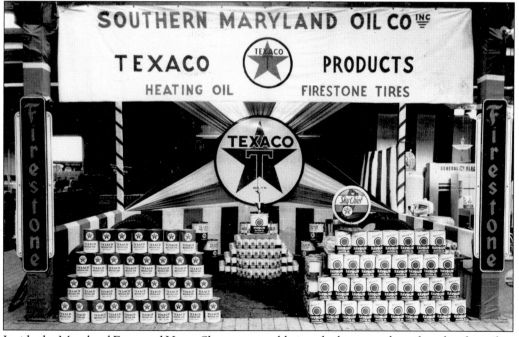

Inside the Maryland Farm and Home Show, one could view the latest products from local retailers and businesses. Southern Maryland Oil showed off their Texaco products and Firestone Tires. To the right, General Electric appliances can be seen. (Courtesy Southern Maryland Oil.)

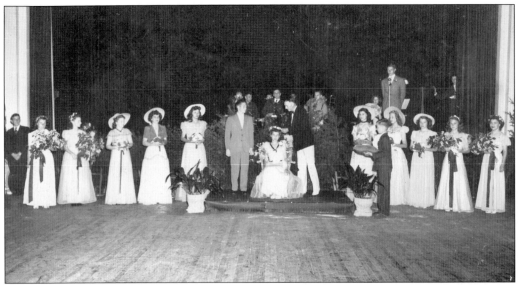

The May Prom was what the graduating class of La Plata High School named their dance in 1947. The queen and her court of princesses were crowned at the dance, which was held in the school gymnasium. There were no limousines; guys usually borrowed their parents' car or were driven by them, and it was usually a double date. (Courtesy SMSC at the College of Southern Maryland.)

The Waldorf Volunteer Fire Department formed in 1949, with 200 charter members pooling their money to build a fire station. For the new Dodge fire truck they needed, it was decided to host a carnival as a fund-raiser. It became an annual fund-raiser for the next 25 years. From left to right are three unidentified, Oscar A. Raba III, and William Cooke. (Courtesy William F. Cooke.)

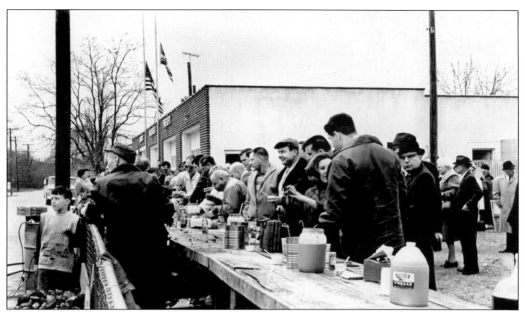

From the 1950s until 1978, the Benedict Fire Station's main fund-raiser was the annual oyster roast. The fire department was established before 1950, but that was the year they incorporated. The little boy on the outside of the fence is Harry Brown Jr., who is helping his father, Harry Brown Sr., on the inside of the fence to serve hungry customers. (Courtesy Colleen and Harry Brown Jr.)

The Indian Head VFD built a new two-story firehouse in 1963 with a large hall on the second floor to hold fund-raisers. At that time, the Ladies Auxiliary was organized under Frances Slavin. A successful fund-raiser was a teen dance in partnership with WPGC radio and Potomac Heights VFD. It was a $2 admission, and soda and snacks could be purchased. (Courtesy Indian Head VFD.)

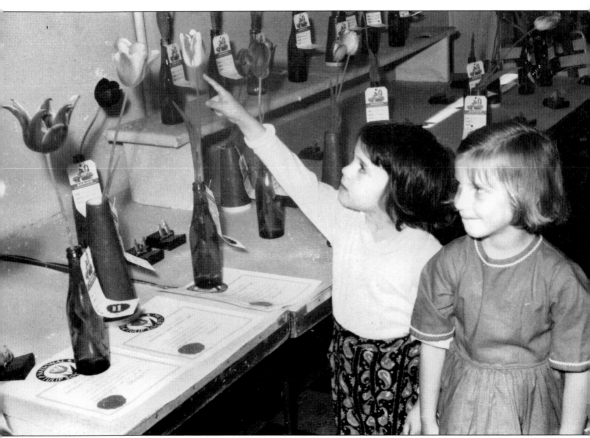

Pointing at a tulip is Nancy Levering next to her friend Janice Lawlor; they are daughters of Charles County Garden Club members Betty Levering and Helen Lawlor. In the spring of 1963, the garden club hosted a flower show emphasizing tulips titled "May Flowery, Showery, Bowery." Betty Levering was chairman of the show held at the Methodist church in La Plata. (Courtesy Nancy Hennen.)

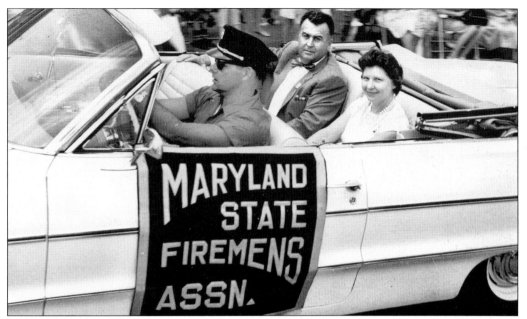

At the annual convention parade for the Southern Maryland Volunteer Firemen's Association held in Waldorf in 1964, William F. Cooke chauffeured the president of the Maryland State Firemen's Association (MSFA), Herman Hare, and president of the MSFA/Ladies Auxiliary, Anita Lochary. The MSFA was first organized in 1889 by a legislative arm to create widow benefits and scholarships for courses relating to fire training or emergency medical services. (Courtesy William F. Cooke.)

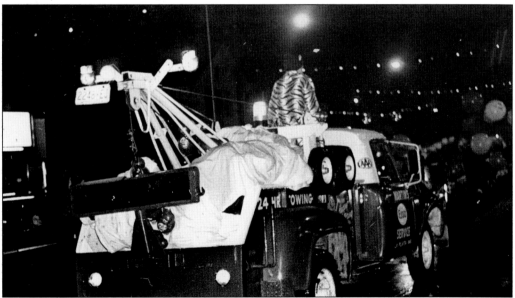

In the 1960s, the La Plata Fire Department held Christmas parades down Charles Street. Church choirs would carol in front of the courthouse, and apples and oranges were given to the kids. Santa would always be the last to arrive on the Old Seagrave fire truck, and the Christmas tree in front of the courthouse would be lit. John Newcomb is riding atop the Martins Garage tow-truck in a Tony the Tiger costume. (Courtesy Kittie Newcomb Collection.)

Aqualand Marina and Campground on the Potomac River was a favorite spot for the Charles County Ambulance Association's annual picnics. They would have a crab and shrimp feast paid for by donations gathered all year by various enterprises such as soda machines at the courthouse and a 20¢ charge to play pool in the squad's facility. Aqualand opened in the slot-machine era then added a campground, airfield, petting zoo, and children's rides. (Courtesy Charles County Ambulance Association.)

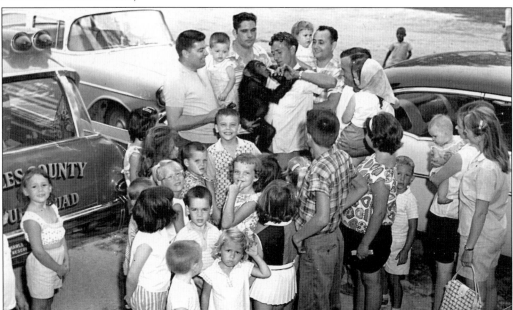

Aqualand's petting zoo was a favorite of the children of the Charles County Ambulance Association's picnic. This photograph was in the early 1960s. The squad's new 1959 Pontiac ambulance can be seen on the left. Directly behind the man holding the monkey is Charlie Spalding, and to his right is Caroll Simpson. (Courtesy Charles County Ambulance Association.)

Nine

FIRE AND RESCUE

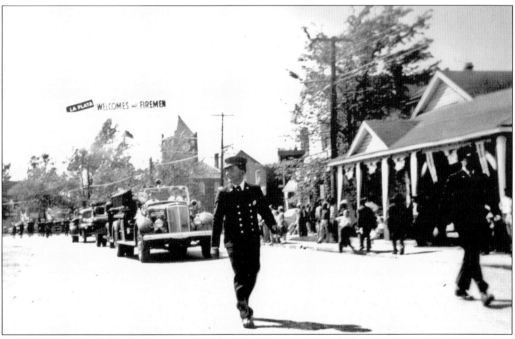

La Plata first assembled a group of firefighters to attend local fires in the early 1900s. Their equipment included a fire truck purchased in 1905, ladders, buckets, axes, and hose. In 1909, the first firehouse was built. By 1929, the town of La Plata had a chartered fire department with 34 members, the first in Charles County. In order to procure more funds for necessary equipment, a firemen's carnival and a firemen's ball were held annually. In 1930, the town provided land for the second firehouse behind Mitchell Motors. In 1930, the first mutual aid to neighboring areas was initiated with the U.S. Navy Fire Department at Indian Head and the Leonardtown Volunteers in St. Mary's County. Pictured is the La Plata VFD in a firemen's parade they hosted in 1949 marching down Charles Street. John Matthews is walking in front of a 1948 Mack pumper with a 500-gallon water tank. The fireman to his right is unidentified. The tall tower behind the fire truck is the original courthouse. (Courtesy Kittie Newcomb Collection.)

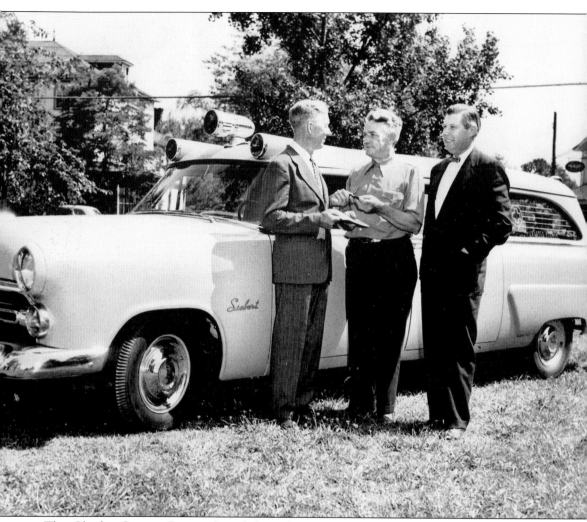

The Charles County Rescue Squad formed in 1952. The Hotel, Restaurant, and Tavern Association of Charles County sought drivers for the hospital ambulance through the local newspaper for a 1951 stretch Ford they purchased. Initially six actively responded, Tommy Posey, J. B. "Snorter" Martin, Danny Raymond, Donald Poole, William Boone, and Michael Stone. Dr. Harris gave the squad training in American Red Cross basic first aid. It was outfitted with board splints, cravats or triangular bandages, a stretcher, and blankets. Basically the crew were trained to stop any bleeding, stabilize the patient, and transport the patient to Clinton Hospital. They had to radio the sheriff's office and ask them to notify the hospital. The photograph is of the 1951 presentation. Pictured are DeSales Mudd (left), the representative from the ambulance company, and County Commissioner William M. Boone. (Courtesy Charles County Rescue Squad.)

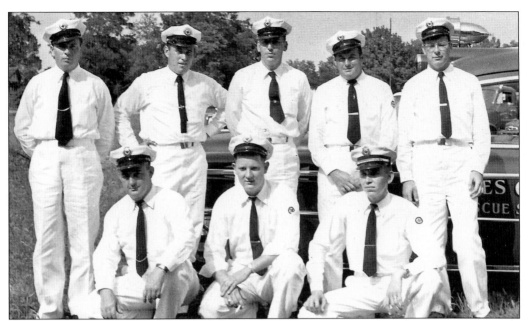

By 1954, the Charles County Rescue Squad responded to 686 calls. They purchased a second ambulance and changed their uniforms to white shirt and pants with a black tie. The squad wore white so they could be seen at night on the roads. Pictured from left to right are (kneeling) Billy Simpson, Pete Barbour, and Walter Scott; (standing) Snorter Martin, Fill Fenell, Dick Landry, Caroll Simpson, and Jimmy Bair. (Courtesy Charles County Rescue Squad.)

This photograph was taken about 1956 of the Charles County Rescue Squad making a presence at the fairgrounds hoping for new recruits. Pictured from left to right are Snorter Martin, who was one of six early active responders; Maxie Bair, who is a life member and past president; John Matthews, who was a volunteer firefighter from the age of 16; Wally Scott, life member and past president; and Caroll Simpson, past president. (Courtesy Charles County Rescue Squad.)

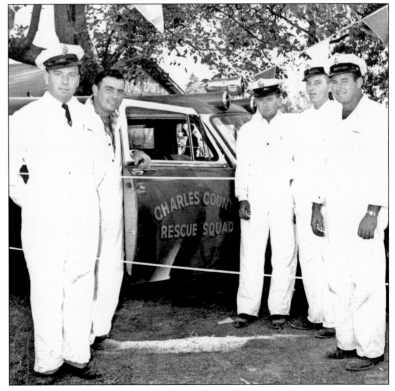

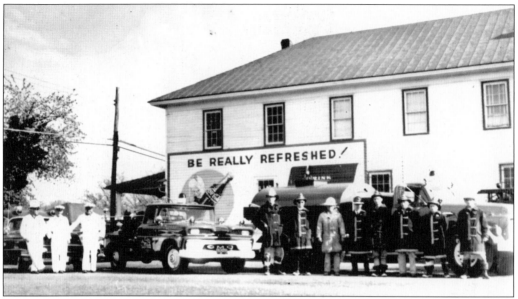

The La Plata Fire Department and Charles County Ambulance Association, pictured about 1962, are preparing for a Veteran's Day parade. They are standing in front of the Hancock and Barnes store on the corner of Charles Street and St. Mary's Avenue. In white jumpers, on the far left, is the Charles County Ambulance Association represented by, from left to right, Vic Bowling, Sonny Posey, and Caroll Simpson. (Courtesy Kittie Newcomb Collection.)

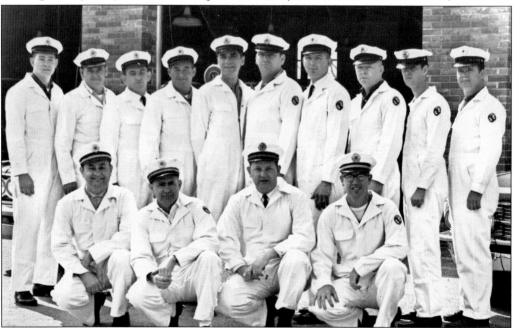

In 1962, the Charles County Rescue Squad got their permanent location on Calvert Street. The squad is assembled in front of their new building. From left to right are (kneeling) Charlie Spalding, Vic Bowling, Pete Barbour, and Harry Clark Sr.; (standing) Ray Brown, Charles Hayden, Sonny Posey, Caroll Simpson, Omar Kendig, Earnie Swanstrom, Joe Cusick, Bob Case, Bob Price, and Bob Bristow. (Courtesy Charles County Rescue Squad.)

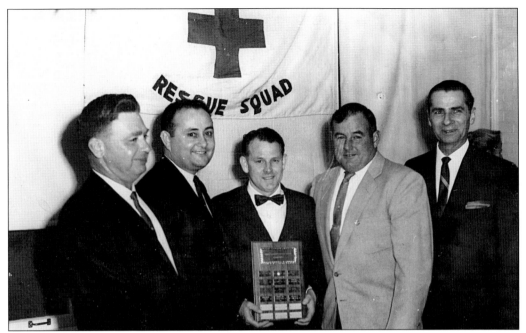

The Charles County Rescue Squad held a member appreciation dinner at the Open Hearth Restaurant, which was on Route 301 in La Plata, in 1966. The men pictured from left to right are Vic Bowling, Charlie Spalding, Ralph Cary, Caroll Simpson, and Omar Kendig. (Courtesy Charles County Rescue Squad.)

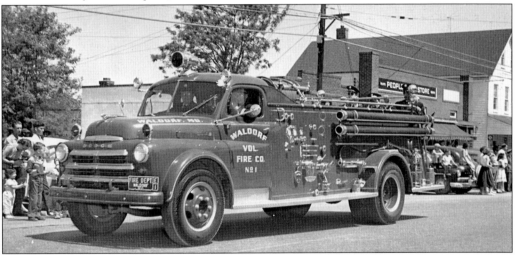

The Waldorf Volunteer Fire Department was formed and chartered in September 1949 after a fire totally destroyed the Waldorf Supply Company. The 200 charter members pooled their money to purchase an acre and a half of land to build a fire station, which the men constructed themselves. Through fund-raisers like their annual carnival, they purchased a 1950 Dodge American Marsh 500-gallon-per-minute pumper truck. The first elected fire chief was William Eschinger, and the first president was Noel P. Dodson. Pictured is the fire truck in the Southern Maryland Volunteer Firemen's Association parade on Main Street in Prince Frederick. The driver is Paul Sterzbach with passenger and fellow firefighter Bobby Walker. On the rear, from left to right, are Billy Cooke, Billy Olsen, and Jack Peddicord. (Courtesy William F. Cooke.)

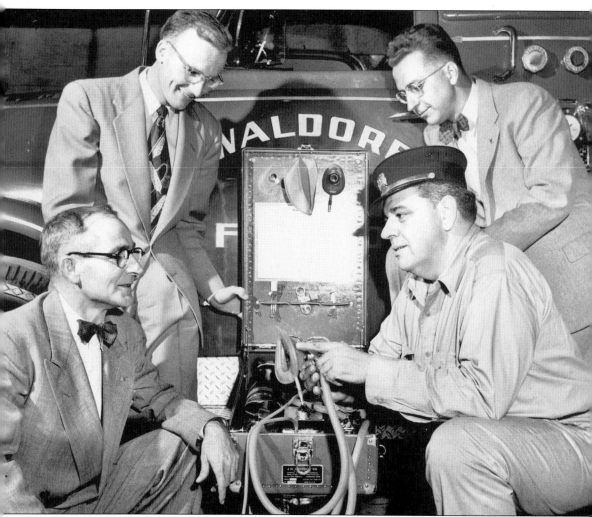

In 1951, the year-old Waldorf Volunteer Fire Department was given an Emerson resuscitator by the Waldorf Lions Club. From left to right are (first row) Rex Brown and Elmer Ager Sr., the third chief of the Waldorf Volunteer Fire Department; (second row) George Bowling and Oden Turner. (Courtesy William F. Cooke.)

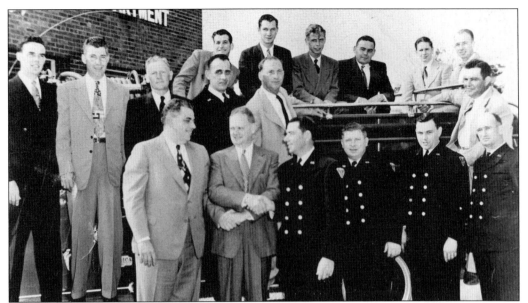

This is the advanced class firemen of the Waldorf and Hughesville VFD in 1952. The members are, from left to right, (first row) Chief Elmer A. Ager Sr., Benjamin P. Poindexter, Spencer Knott, John Istvan, Warren Johnson, and Hampton Milstead; (second row) Spencer Harcourt, Tommy Canter, Paul Burton, Leo Istvan, Paul Stertzbach, and unidentified; (third row) Joseph Jenkins, Jimmy Canter, unidentified, A. Q. Jameson, unidentified, and Hayden Bowling. (Courtesy William F. Cooke.)

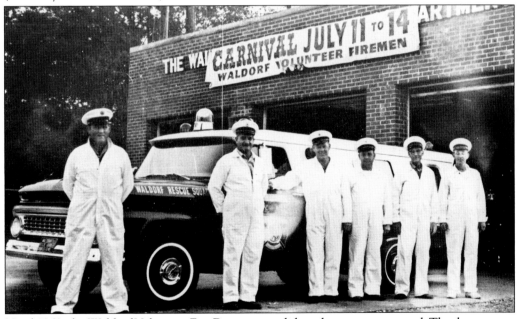

Until 1963, the Waldorf Volunteer Fire Department did not have a rescue squad. The department purchased a Chevrolet ambulance for $8,000, but it was an independent entity. In 1965, the fire department took over operations and was renamed the Waldorf VFD and Rescue Squad. From left to right are Capt. Myron T. Rowe, Lt. Joseph H. Bender, Gerome Jameson, Eugene Talley, Emory Bolster, and Wayne Hamilton. (Courtesy William F. Cooke.)

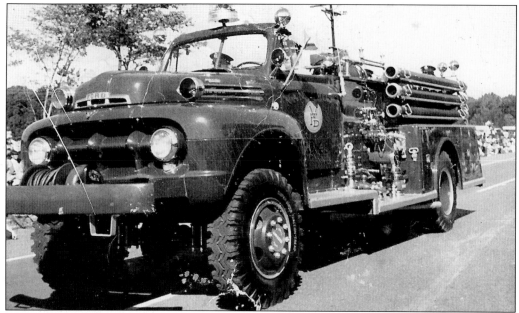

Nanjemoy's volunteer fire department was organized in 1949 with 40 members who went door to door to solicit $1,500 to purchase the first fire truck. The used, 1941 World War II fire truck was stored in Arthur M. Scott's repair garage during the night and brought out and wrapped in blankets during the day to keep the pump from freezing. The first fire chief was Everett Mitchell, and to first president was Samuel "Buddy" Linton Jr. The fire truck in the photograph was Engine 4–2. (Courtesy Nanjemoy VFD.)

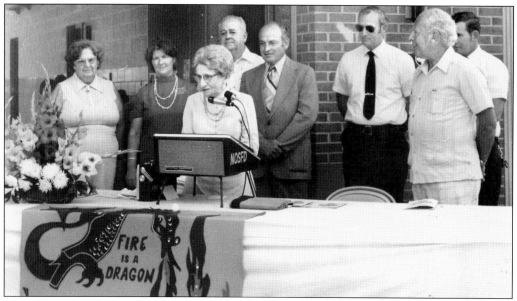

Mary Scott was the speaker for the Nanjemoy VFD dedication service for the new firehouse that honored her husband, Arthur M. Scott, in 1968. Scott donated the land for the original firehouse. From left to right are the first president of the ladies auxiliary, Mary D. Helwig; Alberta Jones; Everett Mitchell; Buddy Linton; Louis Goldstein's driver has on the black tie; former–first president Louis Goldstein in all white; and John Knight Parlett. (Courtesy Nanjemoy VFD.)

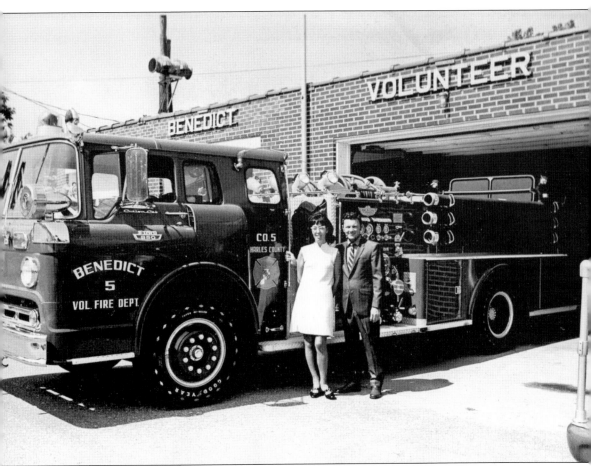

The Benedict VFD and Rescue Squad was chartered in 1950. A few years earlier, locals purchased a used 1929 open-cab International fire engine and parked it behind the Henderson Hotel until Joseph Higdon donated the land on which the first two-bay station was built. Robert and Dolores Buck are pictured here in 1959. (Courtesy Robert and Dolores Buck.)

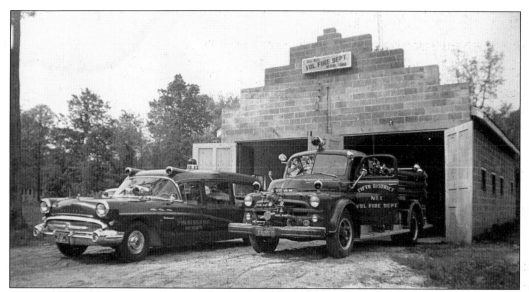

The Cobb Island Volunteer Fire Department and Emergency Medical Service was chartered in 1946 with 15 members. J. Carl Hill was the first president. John E. and Mary Simms donated the property on which to build the firehouse. (Courtesy Cobb Island VFD and EMS)

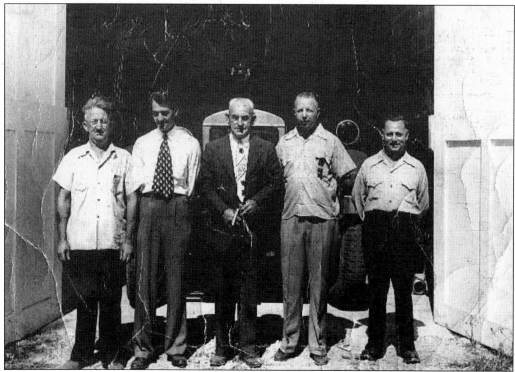

The Cobb Island VFD held a dedication ceremony for the new firehouse on October 10, 1948. Their first fire truck, pictured behind the men, was purchased in 1947 from the war asset sale of surplus vehicles at the U.S. Engineer Depot in Washington, D.C. for $740. The men pictured are, from left to right, Jack Simms, engineer and driver; Carl Hill, president; Harry Carpenter; Captain Wilmer, board of directors; and Cherry Norris. (Courtesy Cobb Island VFD.)

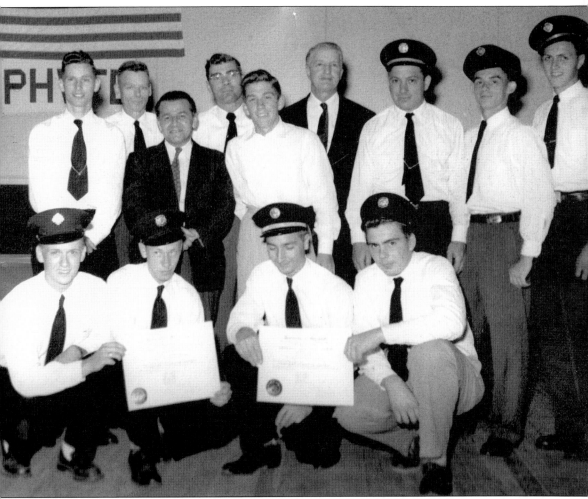

Potomac Heights Volunteer Fire Department went into service in 1950 with a World War II piece of equipment, storing it in the Potomac Heights Mutual Home Owners Association maintenance shop. The volunteers are, from left to right, (first row) Donald Gladwell, Jimmy Oswal, Perrin Agg, and Joey Vering; (second row) Chief Donald Johnson, Pappy Quinlin, Frenchie Gertlin, Carrol Posey, Paul Stillson, Chief Charles Leverin, Arthur Scott, Jimmy Quinlin, and Bryd Raby. (Courtesy Potomac Heights VFD.)

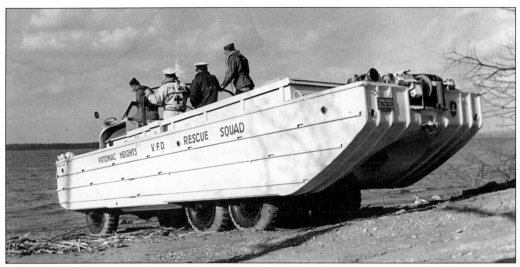

Potomac Heights originally was a dairy farm that sold to the government to build housing for the Naval Powder Factory workers. In 1950, the homes sold to the Potomac Heights Mutual Homeowners Association and the fire department formed. Because of its proximity to the Potomac River, a surplus unit was purchased from the navy for water rescues. Its top speed was 40 miles per hour. (Courtesy Potomac Heights VFD.)

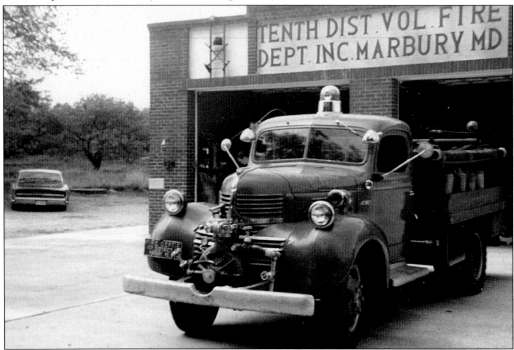

The Marbury VFD was chartered in 1951 with 37 members. Their first fire chief was John Goode, and the first president was Fred Bostian. After incorporating, the first firehouse built was a single-bay building on the Marbury Motor Company property belonging to William C. Abell. A homemade siren was fashioned out of a Model A Ford brake drum and powered by a Model A Ford starter motor connected to a six-volt battery that was manually started. (Courtesy Marbury VFD.)

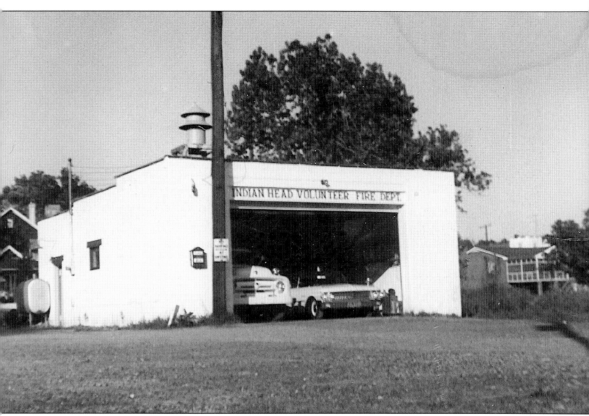

The Indian Head Volunteer Fire Department was organized in 1948. Until then, the Indian Head Division, Naval Surface Warfare Center Fire Department answered calls for the town of Indian Head. Their first president was Peter Rekliss; the first chief was Joseph Mattingly Jr. Their first firehouse, pictured, was built in 1948 with donated material and labor. The siren on top of the building was activated by radio signal by the new fire department radio communications system located in the La Plata Fire Station. It was the first of its kind in the United States. Their first pumper was a surplus army fire truck. In 1963, a new, two-story firehouse was built at a new location, Indian Head Highway and Strauss Avenue. A large hall, located on the second floor, is used for fund-raising. (Courtesy Indian Head VFD.)

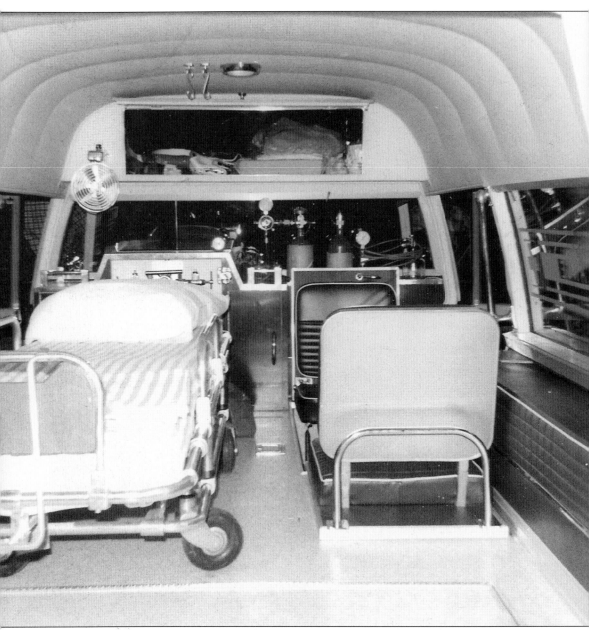

The Indian Head Rescue Squad began in 1954 with the help of a 1950 navy Packard ambulance. The first rescue squad captain was Albert Carbonneau. Pictured is the interior of the used Cadillac ambulance purchased just a few years later. Training for volunteers was a standard first aid course through the American Red Cross. (Courtesy Indian Head VFD.)

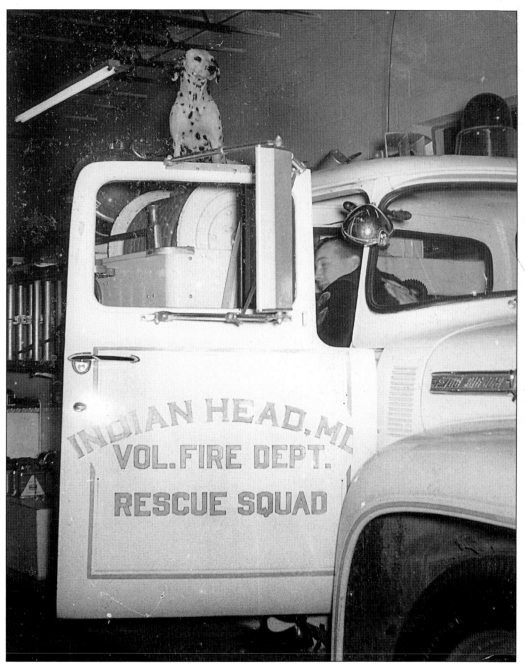

The mascot for the Indian Head Volunteer Fire Department was a dalmatian named No. 90. Grover Barton is in the passenger side of the fire department's first engine, a 1956 Ford American LaFrance 500-gallon-per-minute pumper. It was the first year they started painting their fire trucks white. (Courtesy Indian Head VFD.)

Wayne Higdon took this photograph after a fire drill at the Indian Head VFD in 1963. Pictured from left to right are (first row) John Thorpe, Richard Allen, mascot No. 90, past-chief Frank Catrufo Jr., Frank Molber, unidentified, and David Shaw; (second row) Porter Hamrick, Gary LaFrue, Richard Newman, Francis Knott, and Gary Mullins; (third row) David Hamrick, Ralph Hedges, and Bruce Robey. (Courtesy Indian Head VFD.)

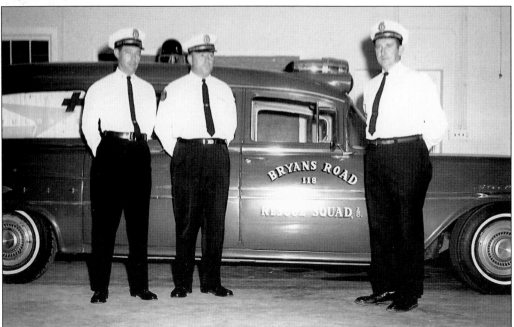

May 25, 1961, 3,300 flyers were mailed to Bryans Road addresses to solicit volunteers for a new fire department. By September 1962, the fire department was chartered. In 1964, a 1957 Pontiac ambulance was purchased and pressed into service with a crew of volunteers that had training in American Red Cross basic first aid. From left to right are Donald Pearson, Elvan Hedges, and Raymond Sliwka. (Courtesy Kathleen Chapura.)

Bryans Road's first fire prevention parade took place in the summer of 1965. Every firehouse in the state was invited, as were commercial businesse, such as wrecker services and beer distributors. Trophies were presented for best appearing overall fire equipment, best majorette group, best marching bands, and the fire prevention queen. (Courtesy Kathleen Chapura.)

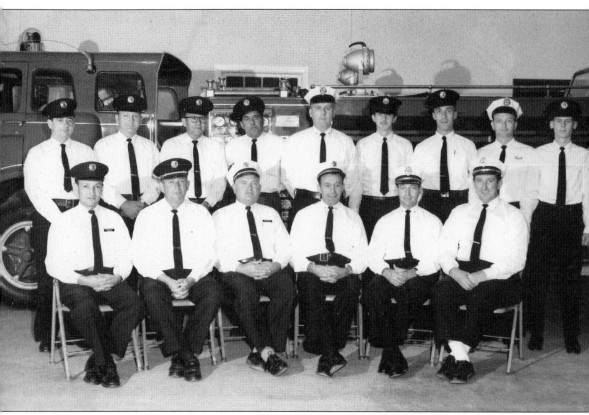

Chartered in September 1962, the Bryans Road Volunteer Fire Department had 16 active members. The first chief was Roy Grubbs, and the first president was Elvan Hedges. From left to right are (first row) Robert Pizza, Edward Baldwin, A. Delbert Hungerford, William Wood, Donald Pearson, and Raymond Sliwka; (second row) William Nottingham, Harold Huntt, Raymond Cornwell, Guy Willett, Paul Sinsel, unidentified, Phillip Townes Sr., Robert Eastburn, and Michael Chapura. (Courtesy Nora Lou Willett.)

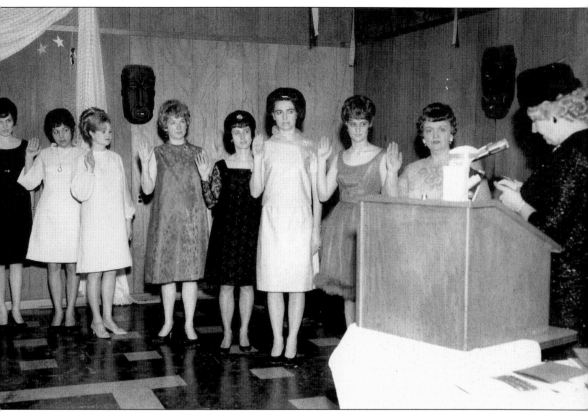

In August 1963, the Ladies Auxiliary of the Bryans Road Volunteer Fire Department was organized. In this photograph, the 1968 officers are being installed at Aqualand. From left to right are Pres. Jean Sliwka, Vice Pres. Rennie Huntt Norris, Secretary Joan Hedges, Chaplain Joanne Petrik, Jeanette Raeborn, Chris Pizza, Ethel Eastburn, and Colleen Batterton. The installing officer on the far right is Regina Mundell, past president. (Courtesy Nora Lou Willett.)

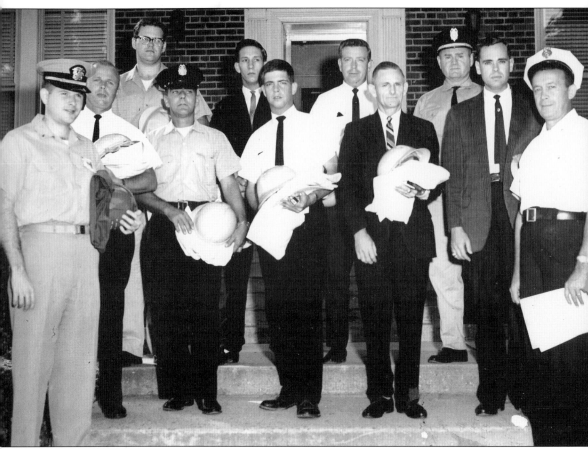

On August 29, 1966, Charles County volunteer fire chiefs and assistant chiefs toured the Naval Propellant Plant, previously known as the Naval Powder Factory, in Indian Head to learn about the sensitive chemical areas on base. They were guided by assistant Naval Propellant Plant fire chief Lt. J. G. Muskopf and W. A. Wood. Pictured from left to right are (first row) George Bowling of Hughesville, George Gray of Accokeek, Buddy Burch of Hughesville, Glen Robey of Nanjemoy, and Gary Echols of La Plata; (second row) Richard Kusnair of Waldorf, Frank Mohler of Indian Head, Walter Golden of Nanjemoy, and John Goode of Marbury. (Courtesy Nanjemoy VFD.)

Ten

TRAVEL

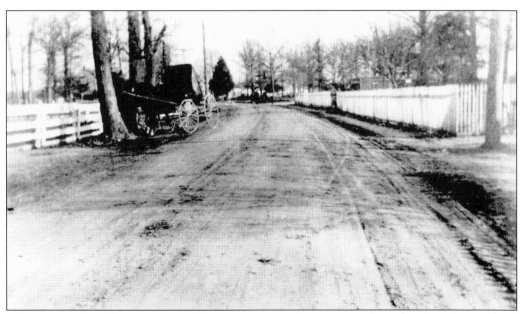

This is an early-20th-century view down Route 5 south, very near the railroad tracks. It is hard to believe that this is the same road as the busy commercial highway that is known today. A few homes still exist along this road; however, they are now used for business. (Courtesy SMSC at the College of Southern Maryland.)

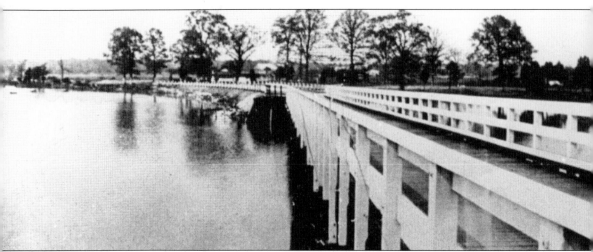

Cobb Island was originally part of Wollaston Manor, a 2,000-acre grant by the English crown to Capt. James Neale in 1642. Neale was commissioner of His Lordship's Treasury and was appointed deputy governor of Maryland. At the time, it was considered a peninsula because at low tide, one could walk or drive a carriage over to Cobb Point, as it was known. Robert Crain bought Cobb Point and renamed it Cobb Island in 1918. The first bridge to the island was opened in 1923. It was a single-lane wooden bridge. This is the view looking at the mainland. (Courtesy Dorothy Kitchen Jenkins.)